
Portraits of Canadian Writers

PORTRAITS
of Canadian Writers

BRUCE MEYER

The Porcupine's Quill

Library and Archives Canada Cataloguing in Publication

Meyer, Bruce, 1957–, author, photographer
 Portraits of Canadian writers / Bruce Meyer.

ISBN 978-0-88984-396-7 (paperback)

 1. Authors, Canadian—Portraits. 2. Authors, Canadian—
Anecdotes. I. Title.

TR681.A85M49 2016 779'.2092 C2016-905864-6

1 2 3 4 • 18 17 16

Published by The Porcupine's Quill, 68 Main Street, PO Box 160,
Erin, Ontario NOB 1TO. http://porcupinesquill.ca

Represented in Canada by Canadian Manda. Trade orders available
from University of Toronto Press.

We acknowledge the support of the Ontario Arts Council and the
Canada Council for the Arts for our publishing program. This project
is also funded, in part, by the Government of Canada through the
Canada Book Fund.

This book is for Kerry, Katie,
Margaret and Carolyn

TABLE OF CONTENTS

INTRODUCTION

Canadian authors are not camera shy, and perhaps in introducing this collection of portraits I can explain why. Over the thirty years that I have been photographing the writers of this country, they have been co-operative, courteous, and above all, photogenic. Captured in these portraits are those who produced a considerable quantity of our nation's recent literature. The power and complexity of what these individuals put to paper is truly astounding, continually innovative, unique, and original. The volumes of poetry and the shelves of novels in my study are testaments to those personalities, many of whom are no longer alive. I look into the eyes of these subjects, these authors, and I realize that what I saw when I looked through the lens of my camera was not the writers who merely wrote works that make us stop and consider who we are, but who created—out of their imaginations—the words and visions of this world they share with us.

I did not set out to become a photographer. Photography, and in particular portrait photography, came into my life when I decided to pursue literary journalism, the *belles lettres* of conversation, during my first year of graduate studies at the University of Toronto in 1980. I had always loved literature. Poetry, fiction and drama have been the nexus of my life for as long as I can remember, and the desire to immerse myself in both reading and writing literature only increased during my undergraduate days at Victoria College at the University of Toronto. Victoria College was a place that had produced a considerable number of Canadian authors—E.J. Pratt (who I had met as a child), Northrop Frye and Jay Macpherson (who were my undergraduate teachers and mentors in Honours English), and a host of graduate writers such as Margaret Atwood, Margaret Avison and Dennis

Lee. Eli Mandel and James Reaney were graduate students with Frye. It was a place where I wrote so many essays each year and read so many books that, when I closed my eyes at night, I saw lines of type floating in my vision.

By the time I reached graduate school at the University of Toronto, I was an addict of the printed word. Half of my master's courses were Canadian literature offerings. It was not enough to study literature. I had to be involved in the literary world of the campus. My friend Brian O'Riordan and I had been attempting to shepherd a campus-wide literary magazine through a series of funding challenges and obstacles. I had edited the *University of Toronto Review* during the final two years of my bachelor's degree, after having served as the youngest editor of the oldest literary magazine in Canada, *Acta Victoriana*, at Victoria College.

The *Review* was a problematic production. Each year we had to raise $6,000 from scratch in order to publish a single issue of the magazine, which was given away free to students across the three campuses. I knew there were good authors on campus and I wanted to make sure their work could be heard. For two years in a row, I made my budget. Then I graduated and began my master's degree. A new group of editors appeared on the scene and one of them wanted to do 'a confrontational interview with Irving Layton', the writer-in-residence for 1980–81. The funding situation was dicey, and O'Riordan and I realized that if anything went wrong, if Layton and the interviewer got into a major fight, the magazine would die. O'Riordan and I stepped in and announced that we would interview Irving Layton together. We had studied Layton's work in depth in F. W. Watt's graduate-level Canadian Poetry class. We had a good sense that we knew our way around in Layton's poetic cosmology. We'd been through Layton's works cover to cover and had explored his archives. We went to interview Irving Layton feeling well prepared.

Layton realized that we weren't looking for sensational answers.

He understood that we wanted to know what went into his poetry, the ideas, influences and experiences that had shaped his creative voice. He saw that we wanted to understand the poetry behind the man and not just the man behind the poetry (as was often the case with Layton interviews). As the interview wound down, Irving looked at us and nodded. 'You guys are good. You should interview Leonard Cohen. He's back in Montreal and he feels forgotten.'

Cohen? Forgotten? We immediately asked Layton if he had Cohen's telephone number. Layton wrote it on a scrap of paper and passed it to us. When we got back to O'Riordan's flat, we called Cohen. 'Irving sent us,' we said. A week later we were on our way to Montreal.

At the time, O'Riordan and I were both working as junior editors for Karen Mulhallen's *Descant* magazine, an outstanding, independent literary journal. When we told Karen we would be interviewing Cohen, she accepted the piece for publication before we had laid down a single second of tape. Findley, Mandel, Acorn, and MacEwen soon followed as subjects for our literary journalism, and the first fourteen interviews we did became *In Their Words: Interviews with Fourteen Canadian Writers* (Anansi, 1985). I began taking photographs out of necessity: I wanted to capture a visual record of the authors when they spoke to us in their own spaces—the places where they wrote and that inspired their ideas.

The odd thing about author interviews is that authors always manage to reinvent themselves as they wish to be seen. No matter how hard we worked to phrase our questions, it was difficult to coax authors to reveal something other than the self-aware persona that emerged from the printed page. If an author such as Al Purdy expressed both raucousness and profound spirituality in his poetry, the persona he presented to us during the interview only reinforced that perception. What struck me when we sat down with writers to discuss their work was that they were assured about who they were

and how they wanted to present themselves. They were image-conscious, but at the same time disarmingly unaware—if they could be that—of the extent to which they were living the *idea* of themselves that they conceived in order to create the work. In some cases, that self-perception was far different from the writer's personality in day-to-day life. What I learned is that it is hard, if not impossible, to separate the author from the author's persona. That persona, the voice in the work and the voice behind the work, was more than an expression of a person writing about what they knew. It was the presence of a personality on the page and in the room in front of us that continually sounded its unique qualities. I soon realized that my duty as a photographer—not just as an interviewer, critic, or reader—was to articulate the voice that I was hearing in their answers. After each interview I would ask the writer to take me to the place where they felt comfortable and where their imaginative work took shape. Some simply stood still. Others would lead O'Riordan and me to a study or to a back porch or a bay window. That is where these photographs were taken.

Listening to the authors was essential. When I looked through the viewfinder of my single-lens reflex or scanned a contact sheet with a slide magnifier (I worked, and still work in black and white, with film, 400 ASA, all natural light, no flash permitted), I realized that what I had to do was more than record the personality I heard or even capture the likeness of the person. I wanted to understand how the words, the personality, and the appearance all fit together like pieces in an elaborate puzzle. Authors are the sum of all these elements and something more that I cannot name but that I always sensed was there. Perhaps it was the sense of self-integration that enabled them to do one of the hardest things possible for a human being: to imagine themselves. I realized I had to see them as more than just faces or I would be doing them and their works a terrible disservice. I wanted my portraits of them to be memorable and in

order to understand what makes a portrait memorable, I began a study of portraiture.

Portraiture is arguably the hardest of all the visual arts to learn. This fact struck me when I pored over the works of such contemporary literary photographers as Jill Krementz (the wife of Kurt Vonnegut), Christopher Barker (the son of Elizabeth Smart and the English poet George Barker), and earlier portrait photographers who had chosen writers as their subjects: Julia Margaret Cameron, Alvin Langdon Coburn, Yousuf Karsh, John Reeves, Arnaud Maggs and the great nineteenth-century French photo-biographer, Nadar. What struck me was that their images were not just snapshots of the person, but serious extensions and reinventions of the art of portraiture, which critiqued and interpreted the authors' works. That's a tall order.

In the middle of assembling the first volume of Canadian interviews that I did with Brian O'Riordan, I took most of 1983 off to go to London, England, to research my doctoral thesis on contemporary British poetry. Two of my favourite haunts for the better part of that year were the National Portrait Gallery and the Renaissance section of the National Gallery. I became fascinated by the works of Hans Holbein and saw how his great canvases such as *The Ambassadors* inspired his successors, who approached their subjects not with a brush and paints, but with a lens that spoke in the vocabulary of symbols, nuances … the fabric of iconography. While I was in England, I interviewed an entire generation of British poets and photographed them, including two future Poets Laureate. The experience was good practice in the art of forging that important link between what a person reads and what a person sees in those who have written it.

When I returned to London several years later on my post-doctoral fellowship, seeking out the lost decade of World War I Canadian literature, I had the opportunity to meet and get to know Julian Vinogradoff, the daughter of the Bloomsbury society doyenne, Lady Ottoline Morrell. Lady Ottoline was an avid amateur photographer,

and in the course of entertaining the A-list personalities of her day (key Modernist figures such as Virginia Woolf, Vanessa Bell, Lytton Strachey, Dorothy Brett, the Lawrences, Aldous Huxley, Ezra Pound, T. S. Eliot and W. B. Yeats to name but a few) at her home in Garsington just outside of Oxford, she made a habit of taking photographs of her visitors. The volumes, now in the possession of the National Portrait Gallery, contained images that chronicled the birth of Modernism.

In one image, D. H. Lawrence sat next to Aldous Huxley and E. M. Forster as they snacked on cucumber sandwiches beneath a spreading ilex tree in Laby Ottoline's garden. In another image, a gathering of men sprawled on the front steps of her house: Charlie Chaplin, H. G. Wells, W. B. Yeats, and a member of the royals known as Prince Bertie, the future George VI. What Lady Ottoline's albums (the five volumes that I was given permission to thumb through by Mrs Vinogradoff) taught me was that authors live in milieus. They rarely write in isolation and prefer the company of other authors when they are not writing. Writing, I realized, is not merely the art of putting the best words in the best order and turning them into a book, but a conversation that the writer has with the world and with his or her fellow writers. What is on the page is a form of instigation that begs for a response, be that response intellectual, emotional, or even spiritual. Into this conversation, the literary photographer enters and throws in his or her two cents' worth with comments, recognizing that the author, the personality behind the work, is creating an icon. A good icon says much more than 'This is a portrait of so-and-so.' A good icon communicates with the beholder on a number of levels.

The idea of living in a milieu is not uncommon in Canadian literature. I consider myself fortunate to have met these writers and recorded their words and their images at a time that now appears to have been a great, golden age for our cultural imagination. It was a time when the heroes of today who are now being cast in bronze

effigy—Al Purdy, Gwendolyn MacEwen, to name a few—were alive and writing and eager to discuss their work with those who would listen. They wanted to share their time and their ideas. I think they knew that what they were doing was going to have a far-reaching, long-term significance, that they were laying the foundation for a vision of how a nation can dream and speak of that dream that others, many of them not born at the time, would build upon. I look at Canadian literature today and I see how contemporary writers—George Elliott Clarke, Halli Villegas, Catherine Graham, Ray Robertson—have extended the range of vision that the Livesays, Birneys, Purdys, Reaneys, and Laytons were articulating. The sad irony is that I didn't realize that I had been in the midst of a very important era in Canadian literature and that I had chronicled it in print with O'Riordan and on film with my camera. Around 1990, I offered this book to another publisher and he dismissed it. 'No one cares about those folks now.' I put the contact sheets, the prints and the negatives away in a filing cabinet in my home office and forgot about them.

About a year ago, I was tidying my office. My daughter asked me what files she could sort through and toss out to make room for new material—manuscripts and research notes of the books I had written in the interim. She came across the drawer of the photographs and began to ask me who each subject was. When I named them she was extremely surprised. 'We've studied these authors in school. And you knew all these people?' She then started examining the images with her artistic eye. 'You really should do something with these. They are important.' She pointed out the images that worked as portraits and the ones that didn't. In all, I went through about three thousand images and over a hundred files of contact sheets and negatives that my mother had assembled, collated and labelled without my knowledge while I was living elsewhere. I owe my daughter and my mother a vote of thanks. If not for them, these images would likely have disappeared. I explained the project to Tim and Elke Inkster, and when

they saw the first batch of images, they responded with enthusiasm. That is how this book came into being.

I am not sure that all of these images are successful. I leave that determination up to the reader. First and foremost, however, a successful portrait makes a statement about its subject. The first thing a portrait says is 'This is what the person looked like', and then if it is working as a portrait should, it proceeds to narrate when and where the subject existed at the moment the portrait was executed—not just in terms of place or even time, but in terms of ideas. If a portrait is working, it makes a statement, a précis of what the subject thought, said, and wanted to communicate through time. The portrait, at that point, becomes a text.

A late medieval or Renaissance portrait, whether *The Arnolfini Portrait* by Van Eyck or Holbein's *The Ambassadors*, is encyclopedic. Every flower, every object, even the pattern in draperies, contains volumes of information that the artist wanted to communicate about the subject. In this respect, the image *is* a text, and the text is there to be read. What informs the text behind the image? The answer is that the informing principle behind a portrait is the same force that enables good literary criticism: the artist's knowledge and understanding of who is being presented, conveyed and explained to the world, so that the portrait acts as a work of criticism, a statement about what the critic/artist/beholder has observed and understood about the subject. In terms of recording an author, a portrait should be more than just a mere likeness. It should introduce the author's work to those who may not have read their books. The old adage that 'a picture is worth a thousand words' is very much at play in what I have attempted to do in these images.

A portrait is more than just a publicity still. It helps an author's public profile to know that his or her face is as familiar to readers as his or her works. Familiarity helps to sell books. I took a number of the later images of authors when I founded the Creative Writing

Program at the University of Toronto's School of Continuing Studies in 1997. I wanted to sell courses where established writers would share their craft with aspiring novices. Recognizing an author's face helped students to recognize the author's work and what the author could teach them. I put the photographs on bookmarks with a description of the course, and distributed the bookmarks around the city. Within weeks, the courses had grown to become one of the cornerstones of the largest creative writing program in Canada.

I once received a letter from Irving Layton with some poems I had requested for inclusion in a magazine I was working on. There was no return address on the envelope. That clever marketer of Canadian literature, publisher Jack McClelland, simply put Layton's portrait on the front of the envelope. If undeliverable, the presence of the portrait seemed to suggest, return to a sender everyone would recognize in an instant—in effect, return to face.

Appearances are important, and there is so much to a portrait that is memorable. The face is the key identifier of a person. We remember someone because we remember their face. That sense of memorability is part of the art of portraiture. The text of a portrait, if it may be called that, is not just composed of symbols, objects, setting, or even poses, but of light, expression, and above all the spirit that emanates from the eyes of the subject, just as I saw that person through the lens of my Pentax K-1000.

I would like to think that the portrait, as a form of art, could be more accepted in Canada than it is today. At one point about two decades ago, Canada had its own National Portrait Gallery in Ottawa. I had dinner one evening with the founder of that gallery, Lorraine Monk, and she told me how she had to bear the pain of watching an important institution that she had founded rise and fall as a result of public apathy and government distrust of cultural iconography. Funding cutbacks aside, there is a trait in the Canadian character which creates suspicion of individuals who become too recognizable.

There is a fear that public personae will inflate egos in a nation where the commonweal, the idea of equality among all, is predicated on making sure that no one becomes too recognizable. More often than not, as many media personalities have discovered, familiarity breeds contempt. Yet, having noted that, there is a longing in the Canadian character for heroes. I am not saying that writers are heroes, but I would like to think that their works articulate, in some small measure, how we cope with our experience, how we indulge our desire for an expansive sense of who we are because we have learned how to dream.

In addition to the portrait photographs, I decided to include brief essays/reminiscences of the authors. These are important. One of the reasons that portraiture is valued as an art form stems from its origins in literature in an almost lost genre known as 'lives'. The earliest 'lives' were the work of Roman authors such as Plutarch and later Suetonius. Plutarch and Suetonius, among others, recognized that behind every face there is a story, and that the identity and culture (to say nothing of the history) of a nation is the product not merely of events but of personalities. As Rome evolved into Christendom, the genre of 'lives' morphed into the basic texts of hagiography, saints lives, in works such as Jacobus de Voragine's *Legenda Aurea* or *The Golden Legend*. The Middle Ages, at least in terms of the visual arts, was predicated on the idea of the icon. A picture had to say a great deal about the personality it represented. De Voragine, among other hagiographers, enlarged the visual experience with narrative so that the faithful not only got to see their favourite saint, but also got to appreciate the venerated ones as living, breathing individuals. On the day set aside to celebrate each saint, their brief biographies were read aloud in churches to provide examples of how life should be conducted. Giorgio Vasari, in the early sixteenth century, secularized medieval hagiography in his three-volume book, *Lives of the Artists*, in which religion's iconic personalities became secularized in the guise

of celebrated artists. Samuel Johnson, and the twentieth century's Lytton Strachey, to say nothing of Canada's Peter Newman, continued the genre of lives. Such books convey to readers the societal values of a given time and place.

In a bizarre twist of literary evolution, the essence of lives as a literary form is still present today when a person picks up a copy of *People* magazine in a dentist's waiting room or in a grocery store checkout line. We still need personalities, even if they are media icons, to fulfill our need to meet those who have spoken to us through the medium of culture. I feel fortunate to have known these individuals in the same way that a Roman schoolboy must have felt on reading Plutarch or a medieval peasant must have understood when he or she was able to comprehend the human being behind the icon.

This collection of photographs and accompanying essays is by no means a complete catalogue of the most important Canadian authors of the past thirty years—though many of them are here—but a small measure of the voices who have contributed to the cultural dialogue Canadian literature has grown into during that period. There are so many I wish I could have met and included—Margaret Laurence, Farley Mowat, Morley Callaghan and many more. I met them or corresponded with them, but I never thought to bring a camera along when I was with them in a restaurant or at a reading. It would have seemed awkward and artificial at the time, and perhaps, something in me thought that those I held as personal icons would live forever.

Our literature is still a very young, very immature literature—we are just now making tentative forays into those literary expressions that signal a certainty and a maturity in a national canon, and chief among those expressions is tragedy. We have, as readers and as makers of a literary culture, steadfastly refused to entertain tragedy. This is partially because the idea of hope is so very central to our sense of who we are, and partially because our sense of poetic justice is ingrained in our political and social institutions. We cannot accept

the destruction of a protagonist as a viable outcome for our imaginations. We seek resolution. We still seek a just society. Perhaps we are just too comfortable, too content with our own situations to accept the discomfort of tragedy.

Looking at the portraits of these writers, I cannot help but feel that there is an exuberance that resides in their eyes. That came naturally. That wasn't posed and I didn't ask it of them. Yes, they were happy that someone had read their work. Yes, they were pleased to have the opportunity to put on record their thoughts about what went into that work. And yes, they were delighted to have their pictures taken. They knew that they were not only going to be seen, but that they would be staring back from a page in a future that was far, far away.

Having photographed British and American writers, I can see that there is something different, something unique about Canadian artists of the written word. When I was photographing all of them, each one wanted to look the camera in the eye, even if I did not choose that image as the final one to represent my understanding of the authors as subjects for a portrait. I think our writers know that we have a long way to go to become the nation that they figured we could become: a nation whose literature is worthy of their hard work, of the dreams they put into words, and of the future for which they laid a foundation in the *terra incognita* of our imaginations.

The Portraits

➤ Gwendolyn MacEwen, who had been married to **Milton Acorn**, loved this portrait of the PEI poet so much that she asked for a copy. She told me she had put it in her bedroom mirror so that when she woke every morning she could remember him. Acorn and MacEwen had divorced in the early sixties. They had shared a cottage on Toronto's Centre Island with Al Purdy, and the chaos of the situation—three poets and creative spirits under one roof—led to the breakdown of the marriage. After Gwen died, Milton's picture was still in her mirror.

Milton was a hard man to know. When he was sharing an apartment with the poet James Deahl on Palmerston Avenue in Toronto's outer Annex area. Milton had appeared to give a reading at the Lennox Street Summer Festival. I asked him for a poem for a magazine I was editing, and he proceeded to write one on the spot. It was an anti-abortion poem, but he broke down in tears as he was finishing it. I have the poem, tear stains and all.

A group of us young poets would gather at James's place on Sunday afternoons in mid-winter. Milton would recite his work and critique ours. He would beat out syllables on a tabletop. The tobacco smoke from the pipes we all smoked would turn the room blue, and the windows would run with steam.

He was ubiquitous, and often riotous, on the Toronto poetry scene. He would appear at readings in the basement of the Main Street Public Library. Often, I would seek him out at the Waverley Hotel, a rundown joint at the corner of College and Spadina. I would buy him lunch. After he died, the people who had brushed by us in a local restaurant, refusing to even acknowledge Milton's presence, stood up on a stage at a local theatre and celebrated him. For me, Acorn remains the ultimate poet/outsider.

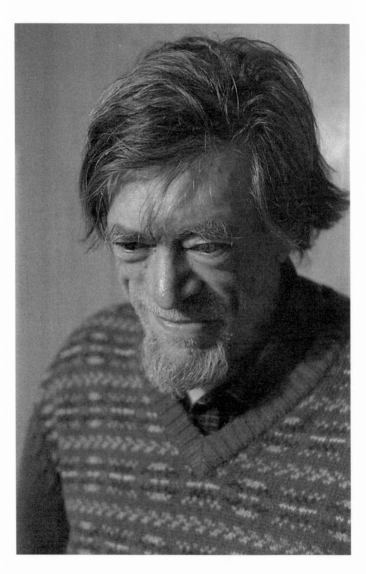

MILTON ACORN

When **Milton Acorn** came to Toronto he stayed in his regular room at the Waverley Hotel at College and Spadina, a landmark next to the famous Silver Dollar Room where singers such as Murray MacLachlan and Bruce Cockburn had cut their teeth in the early seventies. At the front desk of the hotel, a world-weary clerk kept the keys and a partial eye on the comings and goings of the place. The first time I went to visit Milton—I was going to take him for lunch at a vegetarian place around the corner, the clerk said, 'Who?'

When I explained, he replied 'Oh, you mean the professor.'

I was directed up several flights of stairs—the elevator in the place had a permanent out-of-use sign tacked to it—I made my way through the twisting corridors to Milton's room at the back of the hotel, stepping over bodies in the hallway as I went. Through some of the doors I could hear the sounds of men moaning, some screaming. It was like being in a level of hell.

Milton's room was bright and sunny. The floor was littered with papers: thousand of poems that he had written. They were mostly in his thirteen-, sixteen-, or seventeen-line form that he called the 'Jackpine Sonnet'. During his lifetime he published a book of them.

Not long after my visit, Milton gave a reading at Harbourfront and came apart emotionally in front of the audience. He walked off the stage, hopped a streetcar to Union Station, bought a ticket, and headed straight back to PEI without stopping. James Deahl went to Milton's room and gathered up the thousands of poems which became the basis for Acorn's posthumous works.

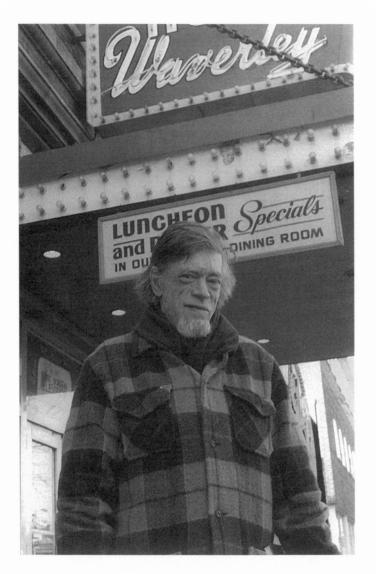

MILTON ACORN

⤳ I met **Margaret Atwood** in 1977 at an event for former University of Toronto writers-in-residence. She was very ill at the time with a bad case of the flu, and no one wanted to go near her. I did. I was editing the centennial edition of the college's magazine, *Acta Victoriana*, the oldest literary journal in Canada, and I wanted to know what she had done when she and Dennis Lee co-edited the production in 1960. I found her to be a wonderful, warm, funny and engaging conversationalist. Interviewing her is, however, a different matter.

The key to interviewing Margaret Atwood, as Brian O'Riordan and I learned, is to show up prepared with a strategy to address major issues in her works. Our interview began badly. We opened with a question about a bird book she had written for children. She disappeared for about fifteen minutes. When she returned, we addressed her most recent book at the time, *Cat's Eye*. That was when the interview became intense. We matched her idea for idea. She liked that. We challenged her and she challenged us. She later told me that she thought our interview with her was one of the best. When my first book of poems was published she wrote me a wonderful congratulatory letter.

Few authors, not only in Canada, but also on the world stage, have commanded such a significant amount of attention. Atwood has never backed down from a contest of ideas. When the tape recorder is on, she is very conscious of what she says. Her public image and her writing have become inextricably linked, and for good reason. She puts herself on the line for what she believes. In this respect, she is the most integrated writer I have met—a person whose public persona argues for reason, good sense and the good earth. I admire her greatly for that. This is a portrait of the two Atwoods I am glad to have known.

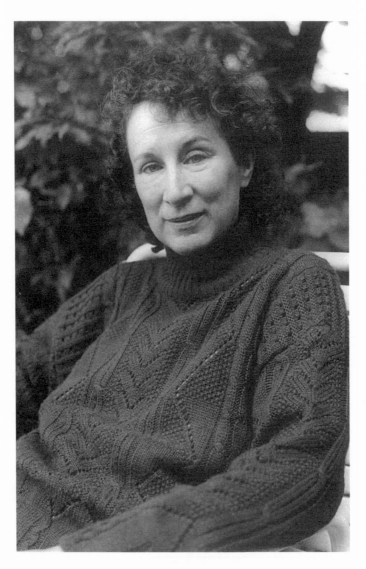

MARGARET ATWOOD

᠉᠍ **Margaret Avison** was one of the most mysterious poets I have ever met. Her mystery stemmed not from the fact that she shunned public admiration and attention during her lifetime, nor from the fact that her poetry was driven by her profound and often emphatic Christianity, but from a wilfulness to avoid contact with worldly things that were not in need of the driving sense of *caritas* she possessed. She was, as far as I could tell, someone who rejected ego in herself and in others. I photographed her while she was working in the Mustard Seed Mission, an institution that looked after the needs of the poor and the homeless.

I first contacted her in 1977 to ask if she would contribute some work to *Acta Victoriana*. She, too, had graduated from Victoria College. Her first response was a polite no. I informed her that the Lieutenant Governor (who had also graduated from Victoria College) had agreed to write the foreword for the issue. 'Am I supposed to be impressed?' she said. I asked her to consider the invitation, and I mailed a polite letter to her with the address of the magazine enclosed. A few weeks later, a poem she wrote for the special issue arrived in the post.

Many years later, we met again at an event for University of Toronto alumni authors at Hart House. She was genuinely glad to see me, and she hugged me. We sat and talked for the entire three hours of the event. We discovered we shared the same birthday and that a close friend of hers was a friend of my parents. She grabbed a copy of her latest book of the time, which had a portrait of a wild carrot growing between cracks in a limestone crag. 'That picture sums up the spirit for me. It says there is hope even in the barrenest of places. I wish I could do that with words. I wish I could find hope and give hope in those places where there is none.'

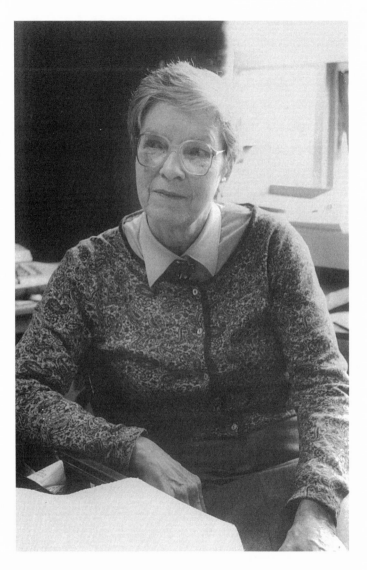

MARGARET AVISON

⤳ I met **Earle Birney** late in his life after he had moved to Toronto. He had been a friend of Howard Sergeant, the British poet and editor of *Outposts* magazine, which was the subject of my doctoral thesis. Birney met me for lunch every two weeks at a Hungarian restaurant on Mount Pleasant, not far from his apartment on Balliol Street. Over lunch, we would discuss poetry. He had done his doctoral thesis on Chaucerian irony and could quote pages of Chaucer by heart. He loved to talk about his early days as an academic. As a young professor at the UBC, Earle had been asked to search out Bliss Carman, who had wandered off before an evening reading to commune with nature and had become lost in the woods. Earle found the Victoria poet stricken and shaken, sitting on a tree stump.

We would go back to his apartment and talk more over coffee. Birney would recite stories of his work as a scaler on a collier—a person who between loads would descend into the sooty bunker and chip away with a scraper at the layers of buildup that had attached themselves to the hold's walls. I loved to ask him about his Mexican days. As a young man, a Communist and a social activist, Birney had spent time in Mexico with the painters Frida Kahlo and Diego Rivera, the filmmaker Luis Buñuel and the Russian revolutionary Leon Trotsky. His Mexican days had resulted in his friendship with the English novelist Malcolm Lowry.

Several years ago, I was at a Frida Kahlo retrospective at the AGO in Toronto and discovered a portrait of Earle on a Communist march in Mexico City with the aforementioned group. I called for the curator. 'There's Earle Birney,' I said to her. 'He's a Canadian poet.' I got no interest from her, but Earle was there.

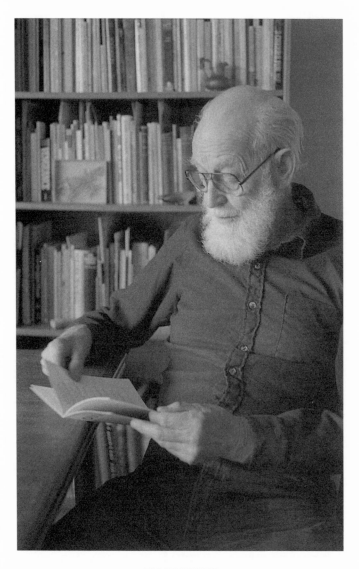

EARLE BIRNEY

⤙ Long before **Neil Bissoondath** became an author, he was my neighbour in the north end of Toronto. He is slightly older than I am. He had come to Canada to room with our friends across the street because his mother and other members of his literary family (the Naipauls) had been close friends of our neighbours. At the time, he was a serious student whom I met at parties. I was a high school student who loved to play road hockey. As far as I could see, he had the makings of a good defenceman.

When O'Riordan and I interviewed Neil Bissoondath in Montreal, the author Bissoondath had taken up a teaching post and was acclaimed for his works. I asked him if he remembered the road hockey. He said he did. He had been terrified that we would break his teeth with our sticks.

One does not become an author easily, and the story of Bissoondath producing his first book is one that I pass on to my students. When he was writing *Digging Up the Mountains*, his first book of short stories, he said that he rose each morning at four a.m. and worked until seven, then got something to eat, went to work at a language school, came home a little after four p.m., had something to eat, went to sleep for several hours, woke at eight, worked until one, and then did the whole cycle over again each day until he had finished his book. That, for me, exemplifies the patience and discipline of writing. What emerged from that discipline was a self-assurance and a belief that an individual's creativity is the key to success. I wanted to capture that relaxed self-assurance in this portrait.

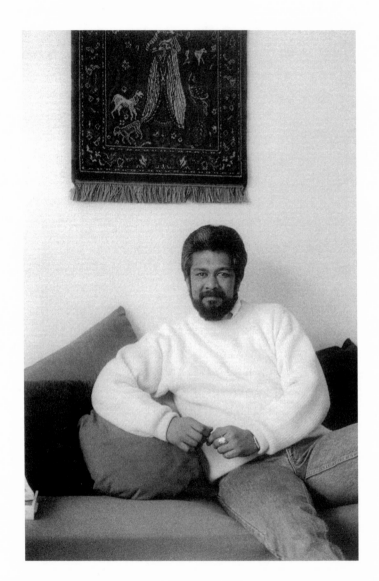

NEIL BISSOONDATH

~~ **Roo Borson** was a rising star of Canadian poetry in 1984 when O'Riordan and I interviewed her for *In Their Words*. Her work had been championed by Timothy Findley while he was writer-in-residence at the University of Toronto in 1980, and when we interviewed Findley he urged us to speak with her. Her recent works, including *A Sad Device* (1981) presented a quiet, contemplative poetry that examined nature as if through a magnifying glass.

At the time I photographed her, she and her partner, Kim Maltman (himself a poet of considerable note and achievement), were living in a street-front flat on Sherbourne Street in Toronto. She was a difficult subject to capture because in both her writing and her personality she is one of the quietest people I have met. That quietness is part of the delicacy and detail she brings to her poetry.

After discussing various poems in her repertoire, many about trees, I was surprised to learn that one of her favourite places to go and write, at least at that point in her career, was Sudbury, Ontario.

'Why Sudbury?' I asked, surprised at her answer.

'I love the lunar quality of the place, the barren rocks, the moonscape surface to everything.' At that point in my life, I had not been to Sudbury. When I finally did see the moonscape she described, a land scrubbed of the trees and topsoil of the Canadian Shield, the result of years of pollution from mining and clear-cutting the forests that once grew there, I understood. Borson is a poet of essences who probes the bones beneath the surface of nature and understands the elemental quality behind life.

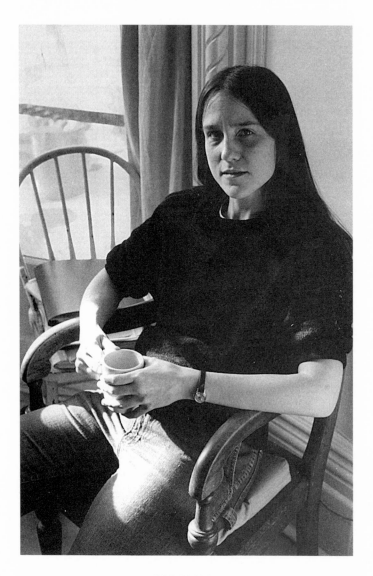

ROO BORSON

George Ellenbogen and I got to know each other at a League of Canadian Poets annual general meeting we'd been invited to in Vancouver in 1983. Over lunch one day, Ellenbogen said he'd rented a car and asked if I'd like to come along that afternoon on a visit to **George Bowering**'s home.

Bowering arrived about forty minutes late, sweating, covered in dirt and beaming with happiness in his baseball uniform. 'We won in the twelfth,' he said proudly. His energy level hadn't waned in the least after an afternoon on the diamond. When I admired the trousers of his uniform, he explained that they (the trousers) had been to the big leagues.

'I got these in Cleveland. They were surplus from my favourite team, the Indians.' Baseball gave us all something to talk about for the remainder of our visit. Ellenbogen, originally from Montreal, was an Expos fan but he'd adopted the Red Sox as his team once he moved to Boston. I had to explain that I was a Jays fan. At that point, their glory days were ahead of them.

Bowering said his favourite position was centrefield. His wife asked us to go outside because her house was very elegant, very tidy and very dirtless. The three of us sat in the garden, threw back some beers—American beers in the Al Purdy tradition, I noted—and we talked about Purdy and the influence he'd had on Bowering's early career. Bowering and his wife, Jean Baird, led the movement to preserve Purdy's A-frame house in Ameliasburgh, and their success is evident today as the Purdy house survives as a writers' retreat. I hope someone, someday, does the same for the Bowerings' fine home.

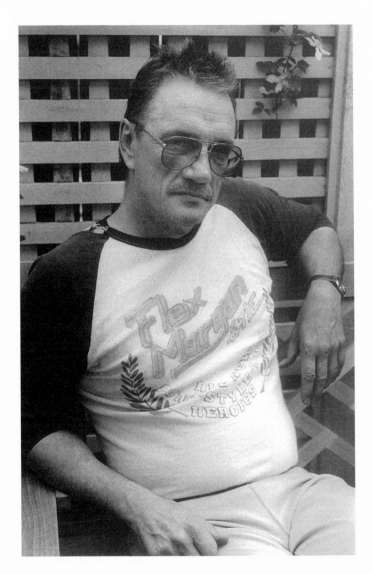

GEORGE BOWERING

⤳ The League of Canadian Poets meeting in Vancouver was a fruitful time where I made a number of lasting friendships, including ones with John B. Lee, Richard Harrison and Robert Priest. Camaraderie among poets is unique. Though poets are rarely embraced by society at large, they are always welcoming to each other. Richard Harrison knocked on my door one afternoon while I was writing (and intending to nap), and said that a group were going down to the edge of the University of British Columbia campus to stroll on Vancouver's famous Wreck Beach.

I was joined by Blaine Marchand, Robert Priest, John B. Lee and **Di Brandt** on the expedition. Wreck Beach was one of the first civically sanctioned nude beaches in Canada. None of us had the gumption to go skinny-dipping, but the power of curiosity got the better of us. Before we encountered any bathers au naturel, Di sat down and closed her eyes and smiled with the sun on her face and the wind in her hair. I had to take her picture.

A few hundred yards further along the beach, the group of us went to sit down for a rest on a large log that had washed ashore. To our surprise, as we straddled the log, a man, totally in the buff, appeared on the other side. Di let out a shriek of surprise. The man woke up with a start, grabbed his straw hat, and placed it over his middle parts. Richard Harrison, always ready to play the diplomat, tried to smooth things over with the man.

'We're all poets, and we didn't mean to startle you. We just wanted to sit down and watch. The sea, I mean. Not you. And she shrieked because, well, you're naked, and she wasn't expecting to see anyone naked because you're the only one here who doesn't have clothes on.' The man grabbed his belongings and clutched them, still holding his hat. We beat a hasty retreat up the cliff, back to our residence.

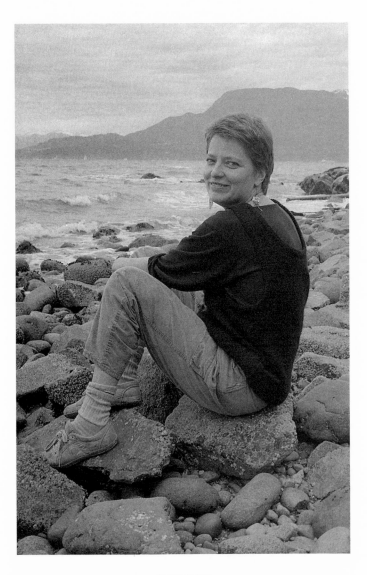

DI BRANDT

᠅ **Barry Callaghan** has been a very influential presence in my life—critic, mentor, publisher, lunch buddy, betting instructor and good friend. He always tells me the truth, even if the truth is hard to swallow. A writer needs someone like that. Before I met him, I knew he had a reputation as an *enfant terrible* in Canadian literary circles. His magazine *Exile* and his publishing house, Exile Editions, had always been on the cutting edge—at times the shocking edge—of Canada's literature. He has never ceased to be someone who has wanted to throw change-ups at the status quo.

I met Barry in 1987 when I was asked to sort out a morass of manuscript he had received from the poet David Wevill. I succeeded in pulling together Wevill's selected poems, *Other Names for the Heart.* Barry and I have since worked together on numerous projects, many of which, such as *The Selected Poems of Frank Prewett* and *We Wasn't Pals: Canadian Poetry and Prose of the First World War* upset many critical and historical apple carts that claimed nothing important was produced by Canadian writers from 1914 to 1918.

The picture I have in my mind of Barry Callaghan is of a showman, his arms spread wide on the stage of Harbourfront when Exile Editions celebrated its tenth anniversary; but the portrait of Barry presented here is of a far more private man, the passionate, intense, inward-looking poet who has penned some of the most moving and beautiful love poetry this country has known. He is a storyteller who possesses a tremendous generosity of spirit, and who always finds something new, true and worth telling inside the largesse of his experience.

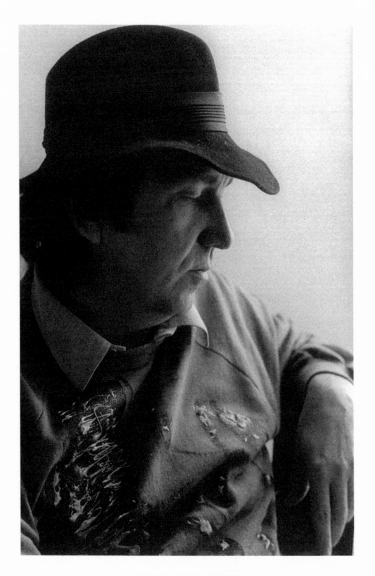

BARRY CALLAGHAN

⤳ I met **Colin Carberry** when he was an undergraduate at the University of Toronto in the mid-nineties, at a time when he was a student of the poet and professor Richard Greene. Colin attended the Taddle Creek Writers' Workshop, an intensive four-day program I ran each July 1st weekend at Hart House. There, Colin Carberry's poetry was 'discovered' by Barry Callaghan, who published the young poet's work in *Exile* and Exile Editions.

I heard through mutual friends that the affable Irish-Canadian had gone to Mexico where he met a woman, stayed, and took up teaching at a polytechnical institute in the city of Linares. Our friendship may have ended with his relocation to Mexico, except that he wrote to me, out of the blue, and invited me to read at an annual literary festival he organized in Linares, a writers' workshop spread across the entire educational community of the city. The Congress, as he called it, was modelled on Taddle Creek and the experience he had there.

In October of 2015, I found myself in Linares, experiencing something akin to culture shock, fascination and sensory-overload—which often happens to Canadians who visit the parts of Mexico beyond the standard tourist destinations. Colin and I discovered we had much in common, as educators, poets, and cultural organizers. His festival brought together poets from all over the world, and the camaraderie of the event enabled me to connect with Richard Greene and Karen Shenfeld, my fellow Canadians, who I had not really had a chance to meet although they lived only miles away from my home. Colin's energy, his wry wit, and his cool head for organization are evident in this picture, taken in the bar of the Hotel Hacienda in Linares.

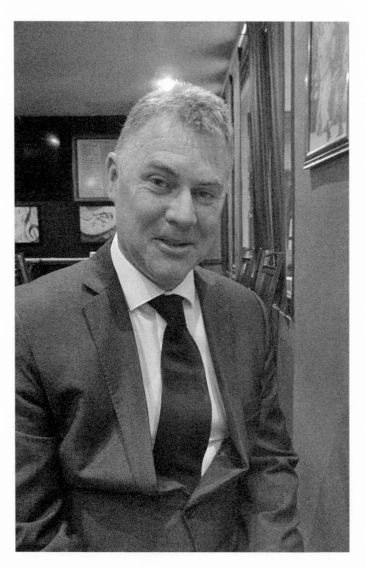

COLIN CARBERRY

⤛ I photographed **Austin Clarke** in 2012 when he came to Barrie to give a talk at City Hall for Black History Month, but our friendship goes back many years before that. When I was an undergraduate, my friend Lawrence Hopperton was invited to a party at the home of novelist James Bacque. The party was in honour of a Scottish poet Larry knew. I tagged along.

Sitting by himself at the kitchen table and sipping a martini (London Gin, dry, twist of lemon, two olives dirty) was a face I recognized from a book jacket. I exclaimed, 'You're Austin Clarke,' to which he replied, 'Be cool, man.'

Several decades later when I was beginning the Creative Writing Program at the School of Continuing Studies, I telephoned Barry Callaghan to see if he had any recommendations for possible instructors. 'Austin Clarke!' Barry boomed. 'He's been living on my couch and he's sitting here stinking the place up with his pipe!' Austin got on the phone and I hired him immediately. That was the beginning of a good reversal of fortune for Austin. Shortly after that, his out-of-print backlist was purchased by several international presses, and he told me he was working on a new novel about Barbados.

Late one afternoon while I was at my U of T office, I received a panicked call from Austin. He had to get his manuscript for the new novel, *The Polished Hoe*, to his publisher, Patrick Crean, and he had no printer. Austin brought the book over on discs, but the files were corrupted and the paragraphs had run together. My assistant, Elise Gervais, pulled the sheets from the Xerox machine while I sat at my computer with Austin, crafting the paragraphs of the manuscript. That night we delivered the manuscript together (all 800 pages of it) to Crean, and Austin took me out for martinis at the Grand Hotel.

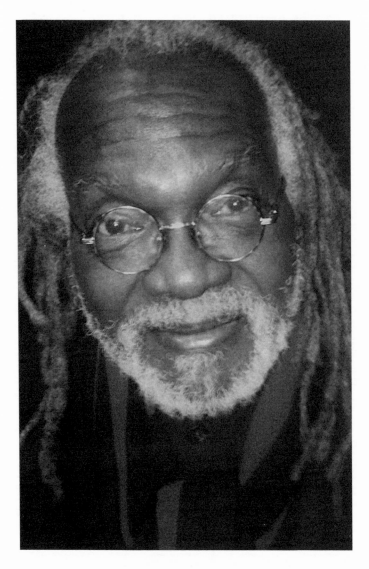

AUSTIN CLARKE

❧ You know when **George Elliott Clarke** is nearby. The lights seem to grow brighter. An intense vibe fills the air. Then you hear a loud, infectious laugh. There are few spirits in Canadian literature who are as well-respected, liked, and applauded as much as George, and every note of that applause is deserved. George possesses a tremendous energy, a spirit of boundless generosity and a knowledge that is staggering in its breadth. I heard him speak for two hours at a literary festival in Windsor in 2011 on the topic of African-Canadian literature. The delivery was smooth, flowing, impassioned, and detailed. I asked if I could get a copy of his talk. He held up a sheaf of blank pages.

I met George in 1980. I received a telephone call from him one afternoon. He announced himself with the bouncing punctuation that carries his voice during readings. He said he had read my work in *The Fiddlehead* and had hitchhiked all the way to Toronto, sleeping in ditches under a firefighter's reflective blanket, to meet me. 'Me?' I asked incredulously. He explained that he had heard that I knew other poets our age and he wondered if he could meet them as well.

The next night I gathered a group of local poets at the Duke of York pub, among them James Deahl, Jeffery Donaldson, Lawrence Hopperton and Andrew Brooks. Richard Harrison drove down from Peterborough. George pulled the manuscript for his first book out of his back pocket: *Salt Water Spirituals and Deeper Blues*. He began to recite his poems with his eyes closed, bouncing up and down on the spot. I knew that evening a legend was being born right before our eyes. The electricity George shared with us that night has become his hallmark. And he has used it to light the way for many others.

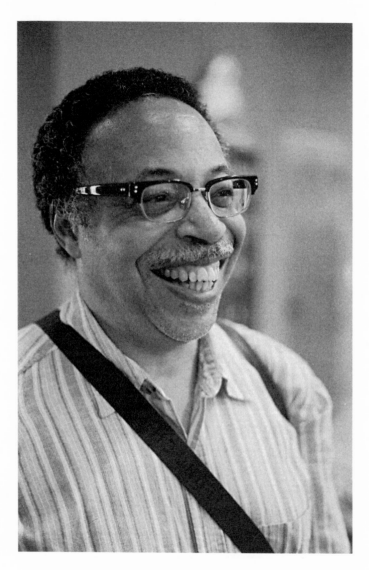

GEORGE ELLIOTT CLARKE

➳ **James Clarke** has been a source of wisdom, wit and encouragement to me in recent years. A retired Superior Court Justice from Ontario, Clarke turned to poetry as a means of finding solace, order and emotional stability after his first wife committed suicide, an ordeal and its aftermath he has written about with tremendous insight and compassion. Through the enormous pain that he suffered, and all the questions that pain brought with it, emerged an incredible spirit and a rare insight.

Born into impoverished circumstances in a small town east of Toronto, Clarke worked toward his education, often going the hard route. The result is a poet who never flinches from being there for other poets, with wisdom and insight. His breakthrough came when he took a poetry workshop with Susan Musgrave, who saw the diamond in the rough in his work and told him to keep writing. She put Jim in touch with Barry Callaghan, who became his publisher. That is how I met Jim Clarke.

Judge Jim is a traveller, a husband, a father and noted jurist, and a level-headed thinker who helps others to see daylight at the end of dark tunnels; but it is his poetry, and the humanity he brings to his verse that makes him remarkable. During a rough patch in my life, Jim would phone every other day and we would just talk. He encouraged me to press on, despite the setbacks of the moment, and having someone to talk to, someone who saw the wit in situations and could help me to see it, was a saving grace.

I had the chance to read with two of my favourite poets—the two Clarkes, Jim and George—at the Niagara Festival in the summer of 2014. That is where I photographed them both. Afterwards, we sat together and had a wonderful dinner in a sidewalk café. Jim nudged me, and offered up the motto I connect to him: 'Life's pretty good, eh?'

JAMES CLARKE

➤ **Leonard Cohen** had just returned from a self-imposed exile in a Buddhist monastery in California when Irving Layton suggested that Brian O'Riordan and I travel to Montreal to interview the sad-voiced troubadour. 'He's at a point of transition,' Layton said.

Our train was late arriving in Montreal, so we raced directly to Cohen's place, the upper floor of a very low, flat-roofed, Victorian row house opposite the Parc Portugal behind Ste. Catherine Street. We had stopped at Queen Elizabeth Station to call to make sure he was there and he said 'Come on over.' We knocked on the door. No answer. I reached up and knocked on his front window (the building was that low). Nothing. Suddenly, the door opened by itself. We stepped in. The door closed behind us.

I looked up the stairs and could see Cohen, in outline, at the top, the light behind him from an upper window. It was dramatic. I said, 'How did you work the door?'

'It is on a string.'

'So the door is a kite?'

'Yes,' said Cohen, and together we both said, 'and the door is a victim.'

Upstairs there was a spread of schnapps, matzah, kosher dills and Montreal smoked meat for us. He showed us around the four rooms of his pied à terre. On top of the electric outlet in the kitchen was a comb-drawing of Irving Layton. On top of the water heater was the bust of Layton that appears on Layton's *Selected Poems*. I asked about the icons. 'Irving is my poetic master,' he said.

In the main room, there was a long table, a chair, and Cohen's guitar in its case, lying in state on top of the table. The only picture on the wall was that of a young First Nations woman. 'That's Kateri Tekakwitha,' he said. 'She's the love of my life.'

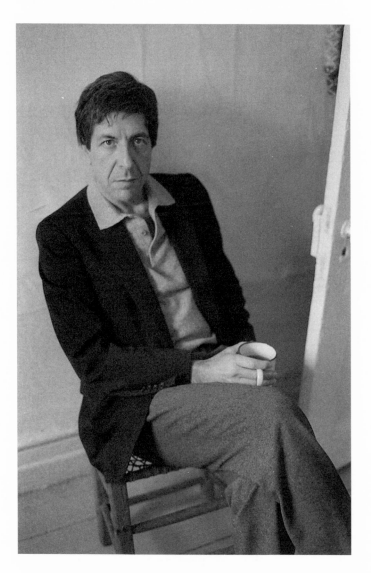

LEONARD COHEN

⤙ During the interview, which was attended by a burly man in an Irish cap who simply sat at the table and stared at us, **Leonard Cohen** was his usual evasive self. O'Riordan and I had read through Cohen's archives, including every interview we could obtain that had been done with him. He seldom gave any interviewer a straight answer. The interview, for Cohen, was—at least early in his career—an opportunity for playfulness. We didn't want playfulness. We wanted to know what was going on inside the mind behind his poems and novels.

We had watched the NFB film *Ladies and Gentlemen ... Mr. Leonard Cohen* in a viewing booth at the Ryerson University Library and we had noticed something unique about Cohen: when he was asked a question, he would pause, a twinkle would come into his eye, and then he would give a funny answer. The interviewers never followed up. We did. We laughed along with him, and then retorted with a repeat of the question. It worked. Cohen opened up to us.

In the middle of the interview Cohen jumped up and disappeared into a closet. The man in the Irish cap said, 'Leonard really likes you guys. I'm Mort Rosengarten. I'm a Montreal artist and I'm the model for Rosencrantz in *The Favourite Game.*' Leonard reappeared wearing *the* famous blue raincoat. 'I look like Sam Spade, don't I?' he said, laughing. Then he put two objects before us. 'These are my most precious possessions.' One was a prayer shawl that had been passed down to him and the other was a Hebrew prayer book his grandfather had written. That gesture in itself was moving, but the moment became holy when Cohen read aloud the prayers of his grandfather and gave us his rough translation of the text.

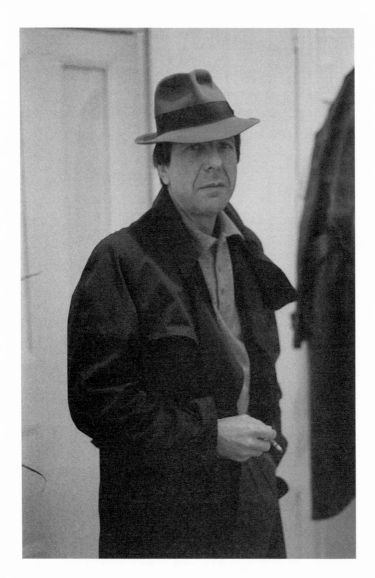

LEONARD COHEN

⤳ I have included a third photograph of **Leonard Cohen** for the simple reason that O'Riordan and I were present at an important moment in Canadian music and literature. After we finished our small meal, Cohen invited us into his living room, where he picked up his guitar and sat down at the stripped pine harvest table. Behind him on the wall was the framed portrait of Kateri Tekakwitha. During the interview, we had asked Cohen about his novel *Beautiful Losers*, and how it had been read into the official record by her advocate when she underwent the process of beatification.

'I've done a lot for that girl,' Cohen responded, and smiled enigmatically. He picked up his guitar and began to play. 'This is a song I'm working on at the moment. I've got the opening bars, but I'm stuck on the lyrics. I want it to be a pop song about holiness, if there is such a thing.'

He began to strum the now famous opening bars of 'Hallelujah', that have become a universal anthem of love, aspiration, emotional agony and transcendence.

Cohen asked if we could help him with the lyrics. He began to play. 'Now I've heard there was a sacred chord/That David played, and it pleased the Lord …' and then stopped and kept strumming. O'Riordan thought we were overstaying our welcome and at that precise moment looked at his wristwatch. Cohen saw him, and looked at my friend: 'You don't really care for music, do ya?' Cohen put down his guitar, and we said good night.

A year ago I was at a party after a Mexican literary festival when someone passed me a karaoke microphone and said, 'Sing something Canadian.' I broke into Cohen's anthem, and a gathering of young literature students all joined in even if they didn't speak a word of English.

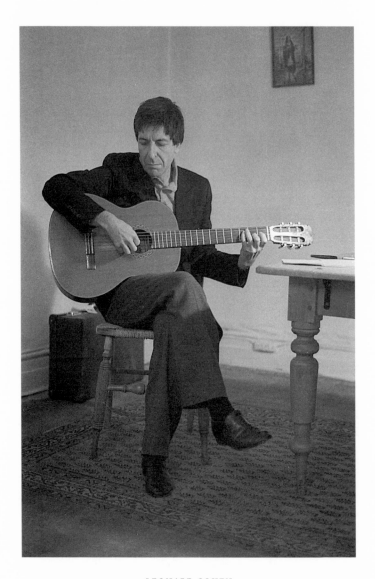

LEONARD COHEN

⤳ My first attempt to photograph **Lorna Crozier** was during her visit to Scarborough College at the University of Toronto when she was a visiting writer there in 1982. At the time, I was a teaching assistant in the English department there. She appeared tense and almost uncomfortable during the shoot in the valley behind the college. Something was not working.

O'Riordan and I interviewed her seven years later when she returned to Toronto to launch a book that included the erotic parody suite of poems, 'The Sex Lives of Vegetables'. I asked if I could photograph her for the interview and she agreed to meet me at Irene McGuire's famous bookshop, Writers and Company, on Yonge Street in midtown Toronto. The Crozier who appeared at the bookstore was much more relaxed. I suggested that we walk south a few doors from the bookshop because there was a fruit and vegetable store there with its wares laid out on tables along the sidewalk.

'Fantastic!' she exclaimed. 'I saw that on the way here and was hoping you'd make the connection.'

The Lorna Crozier who I saw through the viewfinder was relaxed, happy, effervescent, and kept making jokes about the vegetables during the whole shoot. She also could not stop giggling. 'I am going to be remembered for produce rather than poetry,' she mock-lamented. As time and her prodigious output have asserted, Crozier's mark on Canadian poetry is that of an outstanding craftsperson. She is a poet who finds the articulate beauty in the smallest of things—not just vegetables—and celebrates them with a graceful voice that is both haunting and fleeting.

LORNA CROZIER

James Deahl has been a marvellous presence in my life since my days as a young, struggling poet on the Toronto scene. We have travelled together to read in his native Pittsburgh, and have kept up our friendship throughout the years as he moved from Toronto to London, Ontario, to Hamilton or Sarnia.

This photograph of Jim was taken at Grossman's Tavern on the day he read with Milton Acorn (the day of Acorn's heart attack) and Daniel Jones. At the time of the shoot, I owned a Vandercook 2000 letterpress which I housed in my parents' basement in North Toronto. After his honourable discharge from the US Navy during the Vietnam war, Jim had learned to be a letterpress printer, and he taught me how to set cold type. Together we produced poetry chapbooks.

During this period, Jim married his second wife, Gilda Mekler, an artist and editor. Their wedding 'reception' lasted four days at Jim and Gilda's home on Robina Avenue. Dorothy Livesay was there for part of one evening. We got a call from a local fruit store. It was Milton Acorn. Acorn had had his differences with Livesay over some matter that is lost to time, and would not come to the house until Livesay had gone. In the meantime, Milton said, he kept having to buy fruit. By the time Livesay left and the store was closing O'Riordan and I had to go to the store to help carry several bushel baskets back to Jim and Gilda's. We ate fruit for the next three days of the party.

James Deahl was responsible for delivering my first manuscript of poetry to Gwendolyn MacEwen, who, in turn, passed it on to Marty Gervais, who published it. Deahl remains one of the great, under-acknowledged voices of Canadian poetry.

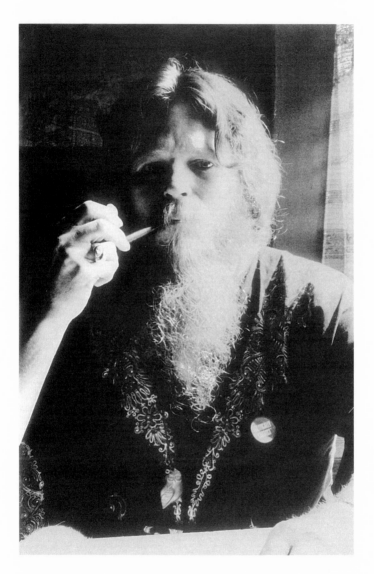

JAMES DEAHL

⤜ In 1977, I had the privilege of having my first professional published poem appear in **Barry Dempster**'s anthology *Tributaries*, a volume of poems about poets. Barry was unable to connect with the anthology's publisher, Howard Astor, who left Barry's editor's copies at a gallery in Yorkville. I agreed to go and pick them up, and was able to present Barry with the first copy of his first published book on a silver platter my mother had ready for the occasion.

Barry Dempster is very tall and his voice possesses an enthusiastic sadness with a note of empathy thrown in. He was one of the many young poets who read their work during the open mic sessions at the famous Axle Tree Coffee House at Holy Trinity Church behind the Eaton Centre. That venue was where I met Dempster, and many other poets of my generation.

One night, after a poetry reading Andrew Brooks and I had attended, Barry kindly offered to help Andrew and me move a very heavy dresser in Andrew's basement flat on Huron Street in Toronto. No sooner had Barry entered the room in which the dresser was located than he knocked himself cold on an exposed beam in the ceiling. Down he went. It took us about ten minutes to bring him around. The dresser remained in its corner.

Several years later, when Barry was working on *Poetry Canada Review*, our paths crossed again.

By then, his reputation as a poet had been firmly established. He had been nominated for the Governor General's Award. Dempster's poetry possesses a tremendous sense of crisp wit that is coupled with a profound desire to look into the life of things.

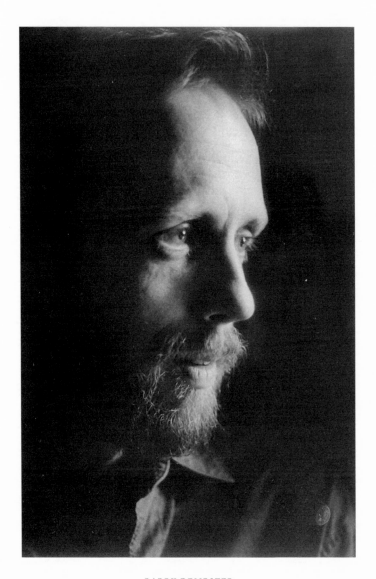

BARRY DEMPSTER

↝ The young poets I hung out with in the late seventies in Toronto all wanted to be **Pier Giorgio Di Cicco**. Not only was his work widely published in literary magazines, but he had a book with McClelland and Stewart. He had a deep, professionally trained voice. His poems were not just written and spoken—they were intoned, melodiously. He had drop-dead good looks and a beautiful girlfriend who was also an accomplished poet. His book, *A Tough Romance*, and the poem from which the title of the book was taken, 'America', would be read by one of us as a ritual at our gatherings, either at the pub or at the apartment James Deahl shared with Milton Acorn on Palmerston Boulevard. We would run into Di Cicco at an all-night doughnut shop on St. George after our favourite literary haunt, the Duke of York around the corner, closed its doors at one in the morning. We would sit with him as he sipped coffee. He would give us advice about how to be poets. He was the epitome of cool. I photographed him in 1983 when I wrote the entry on him for the *Oxford Companion*.

Then, when his career seemed to know no limits, he vanished. Everyone asked, 'Where's Giorgio?' No one knew. Several years later, the *Toronto Star* found him and did an interview with him. He had gone into a monastery in King City to become a priest. A priest? We always thought of Giorgio as someone whose brilliant but acerbic mind, his outrageous and stunning verse, and his black leather jacket with the silver studs and buckles qualified him for anything but the priesthood. When he emerged, the haunting spiritual depth that had been there in his poetry all along became a powerful expression of both personal and cultural wisdom. He became the first Poet Laureate of Toronto and set the gold standard for all future civic laureates across Canada.

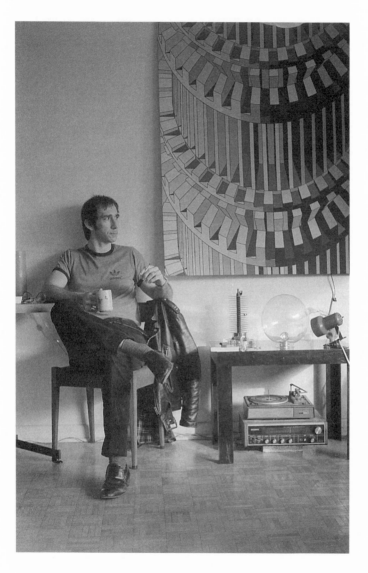

PIER GIORGIO DI CICCO

꘎ During my graduate studies at the University of Toronto, I was invited to co-edit a joint York–U of T anthology. One of the new poets we discovered in the process of sifting through the submissions was **Jeffery Donaldson**. We were in awe of his talent. I woke him one morning in his residence at Victoria College to tell him that his poems were going to be published. He hadn't had anything in print prior to that.

He joined the group of us who gathered at the Duke of York and passed his work around for feedback. We really had nothing to say to him other than to send it out. The major American journals such as *Grand Street* accepted his work enthusiastically. Jeff was to have joined Richard Harrison, Ross Leckie, Lawrence Hopperton and me on a reading tour of upstate New York in February 1982, but he took sick at the last minute. A few years after his magazine triumphs came a book of his poetry from McClelland and Stewart.

Jeffery Donaldson is a poet of nuance, a voice that measures the artistic intent behind great minds. He celebrates such figures as Mahler almost effortlessly. His passion for ideas has recently found its way into the world of criticism, where his astute analysis of contemporary Canadian poetry makes for engaging reading. Following his graduate work at the University of Toronto, Jeffery became Professor Donaldson at McMaster University in Hamilton. His shy, often understated nature is evident in his quieter poems, yet that sense of understatement should never be mistaken for a lack of depth. In this portrait, taken when Jeff was still an undergraduate, I see the reflective, introspective, and meditative power that he brings to his best poetry.

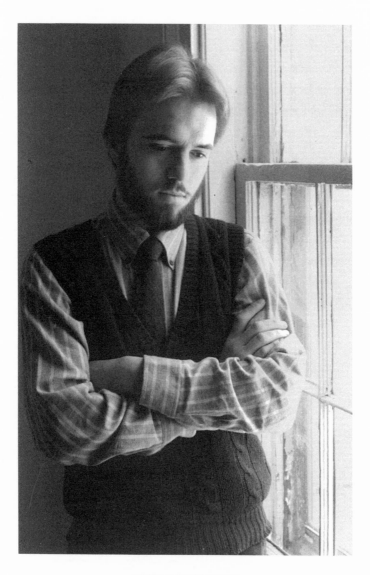

JEFFERY DONALDSON

➤ O'Riordan and I were asked to interview **David Donnell** for *Poetry Canada Review* in 1982 when that tabloid journal was under the editorial direction of Clifton Whiten. O'Riordan and I were just beginning our journey through the voices and characters of Canadian literature, and Donnell had just won the Governor General's Award for Poetry. We prepared the questions with considerable depth and an acute sense of detail to draw out the poet's best answers. Donnell did not want to be recorded. He said he would write the answers and send them to us. About a week later, I received a telephone call from Whiten to say that Donnell liked the questions but did not want to be interviewed by us. 'He said you two are not of sufficient stature to interview him.' The interview never appeared in *Poetry Canada Review* and Donnell missed out on being a part of *In Their Words* and *Lives and Works*.

In the interim week, however, I had gone for a long walk with Donnell to Kensington Market, where he wanted to be photographed. He talked most of the way about buying mangoes. On the way back, I asked him if he would stand for a few moments in the Little Cloister at University College on the U of T campus. That is where this photograph was taken.

Many years later, as I was establishing the Creative Writing Program at the U of T's School of Continuing Studies, I invited Donnell to teach a course in poetry. He did not own a sports coat in good enough condition to appear before the students, so Barry Callaghan went out and bought him a navy blazer which Donnell wore to every class.

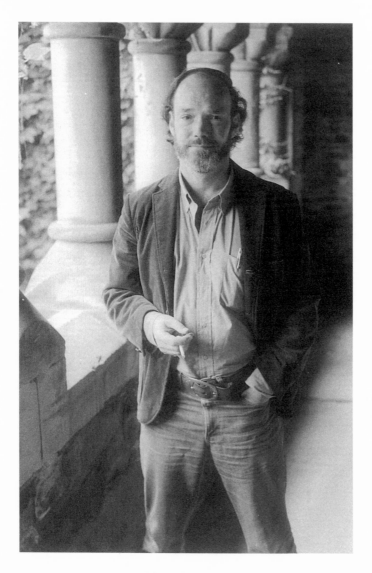

DAVID DONNELL

➳ **George Ellenbogen** introduced himself to me in Vancouver at the League of Canadian Poets annual general meeting in June of 1983 as Leonard Cohen's half brother. 'Really?' I asked, wide-eyed.

'Well, not really. Poetically,' George replied. 'Louis Dudek published my first book in tandem with Leonard Cohen's first book, *Let Us Compare Mythologies*.' George was astounded when I told him his book had been published on Tuesday, April 23, 1957. 'Why yes!' he exclaimed. 'But how do you know it was a Tuesday?'

I told him the story about a photograph Earle Birney had. It was taken at exactly (as noted on the back) 3:45 p.m. on April 23, 1957. The photograph of E. J. Pratt, Earle Birney, Irving Layton and a very boyish and chubby Leonard Cohen, was taken at Diana Sweets Restaurant on Bloor Street. I explained to George that the poets had gathered to celebrate the first copy of *Let Us Compare Mythologies* (which in the photograph protrudes from Cohen's trousers pocket) and that I knew it was a Tuesday because it was taken at the exact moment I was born in Toronto General Hospital, about ten blocks south of where they were standing.

After being brought into print by Louis Dudek (he who said that to be a poet at twenty is to be twenty, but to be a poet at forty is to be a poet), George had a successful poetic and academic career at Tufts University near Boston. He invited me to come by his cottage on Cape Cod when he learned I spent my childhood summers there, but that has never happened. His Canadian upbringing and early career may be a distant memory, but Ellenbogen remains a productive and articulate poet and a great supporter of his students.

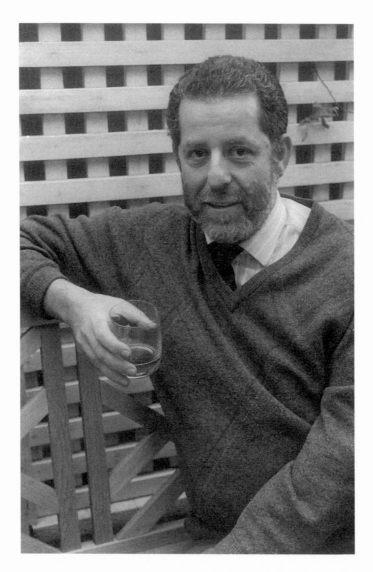

GEORGE ELLENBOGEN

During my undergraduate years at the University of Toronto, there were several writers and poets who I met in my classes or while editing student magazines on campus. One was Anne Michaels, and another was **Cary Fagan**. Cary, with the poet and archivist Bruce Whiteman, started a prestigious little magazine *Harvest*. I recall submitting work to Cary's magazine and having several poems published in it.

Our paths crossed several years later at readings and various literary events in Toronto. He told me he had a letterpress in his living room, and I thought that was a great idea. It inspired me to buy my own Vandercook when the opportunity arose. Shortly after Cary won the City of Toronto Book Award for a collection of short stories, I was tasked to establish the University of Toronto's first Creative Writing Program at the School of Continuing Studies. I needed younger writers who had already made their mark on the city's literature, and who were at that important point in their own careers where their success had not made them forget what it was like to be a young writer. I needed informed, experienced instructors who would bring a creative empathy to the classroom. Cary was one of those writers I chose to form the original nucleus of the program.

Over the years, Cary Fagan has created a very broad body of work that demonstrates his outstanding skills in a number of genres. Young writers need to learn from those who know how to cross boundaries of genre and theme, who understand what it is like to live and write about their environment—in this case, the city of Toronto. The students appreciated what he brought to the classroom. His work, as is the case with many Canadian writers, deserves a much broader hearing.

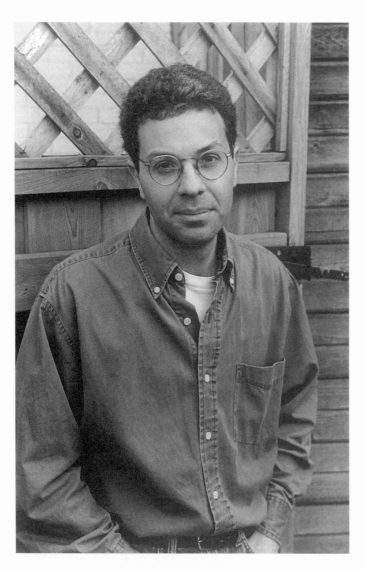

CARY FAGAN

When Andrew Brooks and I were traipsing through England as undergrads abroad in the summer of 1979, we paused on Piccadilly in front of the famous Hatchards bookstore. Copies of the novel *The Wars* by **Timothy Findley** filled the front window. Pride swelled in me. Here was a Canadian writer whose book was prominently displayed in the front window of a major London bookseller. Andrew pointed out that Findley was going to be writer-in-residence at the University of Toronto starting in September, and within hours of his arrival on campus, Brooks and I were there to welcome him and present him with our manuscripts.

Findley liked our work. He selected poems by Brooks, Borson, Kim Maltman and me for inclusion in a special issue of the university's alumni magazine. At the end of the year, Tiff, as he asked us to call him, threw a party at his famous home, Stone Orchard, near Cannington, Ontario. His partner, William (Bill) Whitehead, showed me around the house and grounds. There was a brick cat house that was heated with prototype solar panels, and there was a low, log cabin structure almost buried in the ground. It was an old root cellar.

'Very boy's own, eh?' said Bill. 'This is where Tiff wrote *The Wars*.' I could see the similarities between the root cellar and the trench dugout in the novel. The partygoers were invited to have a swim in the pool, and I was told to change in Tiff's room. Above the head of the bed was a large collection of Penguin Classics, mostly Aristotle and Plato. They had been well read, and when I opened one I found Tiff's handwriting throughout.

O'Riordan and I interviewed Findley shortly after the release of the epic *Famous Last Words*, a novel based on Ezra Pound's character Hugh Selwyn Mauberley. This portrait was taken at the Four Seasons Hotel in Toronto's Yorkville district during tea.

TIMOTHY FINDLEY

◦◦ **Kate Marshall Flaherty** is one of the most charming and pleasant personalities on the Canadian literary scene. She is also a very fine poet, a grassroots voice whose work appears in anthologies and has just hit its stride with a series of accomplished and engaging books of poetry.

I met Kate in 2003 when I was asked by St. Michael's College Continuing Education Program to come and teach for them (at one point, I taught eleven different courses for them in a year on diverse topics ranging from the Great Books to Epistemology). One of the courses I was asked to do was a creative writing poetry workshop that Albert (Al) Moritz had run for many years, but that he had had to relinquish when he received tenure at the University of Toronto. That class was special.

Some of my students from the University of Toronto's School of Continuing Studies program came over and joined me in the workshop. I consider that Saturday-afternoon class to have been a dream team. Sue Chenette, Julie Roorda, Halli Villegas, Peter McEwen, Ruth Roach Pierson, Mary Aird Rutherford, Rosemary Clewes and Kate Marshall Flaherty, to name but a handful of the dozen, all published books during the years that we met or shortly thereafter, and Ruth Pierson's was nominated for the Governor General's Award. Those poets all became award winners. Al gave those poets the foundation, but in hockey terms I like to say I took them to the playoffs and the finals.

I have managed to stay in touch with the group. They have become engaging voices on the Canadian poetry scene. I ran into Kate in the summer of 2015 and invited her to read in Barrie, where this photograph was taken on a beautiful July evening outside the Unity Market Café.

KATE MARSHALL FLAHERTY

➤ I became the inaugural Poet Laureate of the City of Barrie in 2010, and was invited by the Edmonton Poetry Festival to read as part of a coast-to-coast laureates celebration, an event that is now available on CD, titled *A Poetry Map of Canada*. During my stay in Edmonton, I hung around with friends Marty Gervais and John B. Lee, and **Eric Folsom** joined us to make up the fourth for a full table.

I was intrigued by the violence, the Gothicism, and the air of film noir that defines Folsom's poetry. I detected a kind of Robert Frost accent and he told me that he had grown up in Massachusetts—I could easily pick out the accent beneath his newer Canadian voice because I had learned to talk at Cape Cod and had a thick Boston accent until I was sent to speech class at the age of five.

Eric and I met up again the following October in Windsor, Ontario, when Marty Gervais organized a similar gathering of Canadian Poets Laureate for a reading at the old Hiram Walker Mansion. The event drew over four hundred people. During the day, we toured high schools in the Windsor area and spoke to several thousand students in the process.

Late one evening, I ran into John B. Lee in the lobby of the hotel, and he asked if I wanted to go for a beer. Eric happened to be passing by and he joined us. The three of us sat outside on Ouellette Avenue and talked well past closing time about poetry and life. Eric is a great conversationalist and one of the politest poets I have had the honour of knowing. His poetry is a poetry of masks in which the unexpected rears its head and never ceases to surprise.

ERIC FOLSOM

➤ **Northrop Frye** was my professor and my mentor. I first saw Frye in high school when we were shown the NFB film *Journey Without an Arrival*. Frye later gave me a copy of the script for that film. It is one of my prized possessions.

As a young student arriving at Victoria College, I was overwhelmed by the size, scope and majesty of the university. I felt lost. One day, I was standing at the bottom of the grand staircase in Old Victoria College staring at a large composite of the previous year's graduating class and wondering what they had that I didn't seem to have. I didn't hear anyone approach, but a voice asked me, 'What are you looking for?' I turned and it was Frye. I explained that I didn't think I could make it. He was on his way to class, but instead of heading up the stairs, he motioned me into Alumni Hall where there was a large oak case containing the composites of all the graduating years since about 1850. He pulled out one of the frames, and tapped the glass with his finger. 'Class of '33', he said, and turned and walked away.

In the tiny oval, I saw a bespectacled, thin, geeky young man, just like myself. Below it was 'H.N. Frye'. That small gesture gave me the courage to get on with my work. In my final year, I won the E.J. Pratt Gold Medal and Prize for Poetry, and the donor, Mrs Ruth Markowitz, decided to break anonymity. Her husband, Jacob Markowitz, had survived the Death Railway in Thailand and had returned to Canada where he worked with Pratt on *Canadian Poetry Magazine*. My sister and I did a retrospective interview collection with Pratt's daughter, widow, and Frye, and I photographed my mentor in his office. During my graduate work, we met briefly every two weeks, just to talk.

NORTHROP FRYE

A summer's day at Al Purdy's A-frame house in Ameliasburgh, Ontario (a house built by hand by Purdy and Milton Acorn), was often a trigger for a raucous party. When O'Riordan and I arrived to talk to Purdy, the party was well under way. Purdy and **George Galt** had gotten into one of the two fridges crammed with American beer long before Brian and I had even left Toronto.

I thought it would be a good idea to warm Purdy up—and possibly sober him up, just slightly—before we turned on the tape recorder and fired questions. Galt decided to sit in. He and Al had come by a box of Cuban cigars (they didn't offer us any, alas), and I snapped this picture of George as he was sitting at Al Purdy's kitchen table.

After coaxing everyone outside with the blessing of Eurithe Purdy, I started snapping away. At one point Al announced that he had to take a piss. Galt responded with a quip I don't recall, and Al said, 'I'll just do it right here, then, how's that?' I have a picture (not included in this book) of Al Purdy attempting to urinate on George Galt, with Galt leaping for safety in the process.

In later manifestations, George Galt became a distinguished and successful travel writer, and was editor of *Saturday Night* magazine. Our paths never crossed again after that long, hot, rather interesting afternoon at Purdy's home. Galt walked down to the water's edge of Roblin Lake and remarked that there were more ducks than usual that year, to which Al responded that the ducks 'didn't know a damned thing because there's no fish in there this year and they swim around in circles looking for them. It would be easier if they applied to the Canada Council for a grant.'

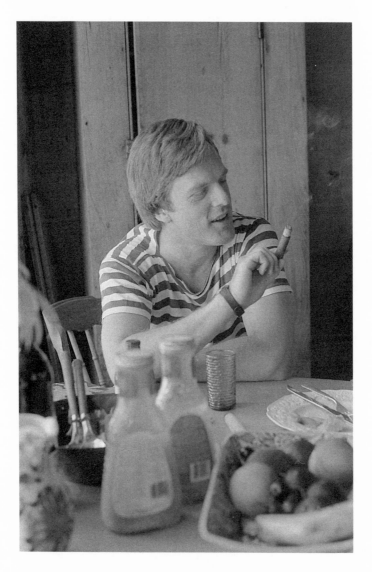

GEORGE GALT

᠅ I had heard **Marty Gervais** give readings in Toronto but I had never met him until Gwendolyn MacEwen sent him the manuscript for my first book of poems. Over the years, Marty has been more than just a fellow poet: he has been a publisher, a fellow hockey enthusiast, a cultural organizer, a newspaper editor of my work, and, above all, a close friend. This photograph was taken shortly after the publication of my first book of poems, *The Open Room*, when I went to Windsor to give a reading.

When I taught for a year at the University of Windsor, Marty would often come around and pick me up so we could go to his sons' hockey games on the Canadian side of the river or to Detroit Tigers games on the other side. He once bet me a Tiger Stadium hot dog that I couldn't write a poem about Astroturf. I won and the dog was a good one.

During the winter, in the midst of a heavy blizzard, I fell ill with a serious bout of food poisoning. The river city came to a halt. I was becoming dehydrated very quickly, was too weak to go out, and was advised to either get to a hospital or get some 7Up and stir salt into it. Marty phoned and asked what I thought of the snow. I told him about my predicament. About twenty minutes later he arrived at my apartment door with a bag full of large bottles of the soft drink. I asked him how on earth he had managed to get through. In a very Marty moment, he responded, 'It's only weather.'

Born Charles Henry Gervais, Marty took his nickname from the Peruvian saint Martín de Porres. What is often overlooked about Marty is his profoundly spiritual side that is apparent in his interviews with Mother Teresa and Desmond Tutu and often as a beautifully haunting presence in his own work as a remarkable poet and a gifted teacher.

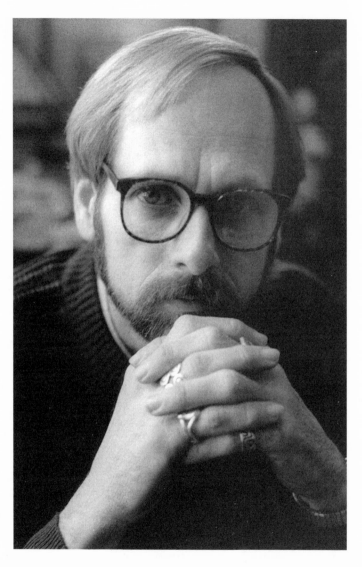

MARTY GERVAIS

O'Riordan and I went to **Graeme Gibson**'s house in Toronto's Annex district to interview him, and this photograph was taken in the dining room of the home he shares with Margaret Atwood. He sat in the window and puffed on his cigar. I asked him how he managed to control the smoke and keep it from wafting through the house. He pointed to a black candle known as a Lord Byron. Magically, even as he puffed on the flame, the smoke evaporated into the thin air. He claimed it was magic but had to admit that he wasn't sure how the candle worked.

Gibson was an inspiration to O'Riordan and me. He had done one of the first volumes of interviews with Canadian authors for the fledgling House of Anansi Press in the late sixties—our *In Their Words* was considered to be a follow-up volume to his Anansi book. His astute sense of literary remarkability led him to the works of such authors as Alice Munro and Margaret Laurence. His conversations are still considered seminal to the study of the writers he chose to feature.

For a Toronto writer, there is a tremendous sense of isolation, loneliness, and defiance in his characters and the settings in which they are located, whether they are habitués of Mount Pleasant Cemetery or pioneers bent on using mastodon bones for perpetual-motion machines. The interview we did with Gibson, alas, has never been published. It would have been part of *Lives and Works*, but he asked that it be withdrawn because the book also contained a remarkable conversation with Margaret Atwood, an interview that she has said is one of the best that had been done with her up to 1991. A gifted writer in his own right and an avid birder, Gibson's fine works are memorable.

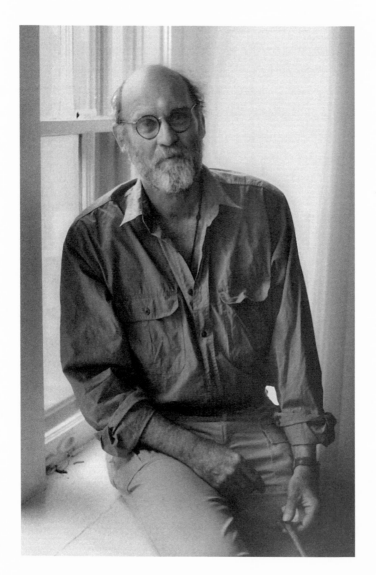

GRAEME GIBSON

⤳ I met **Catherine Graham** in 1995 when we read together at an outdoor poetry festival one fine summer afternoon in Collingwood. At that point, she was awaiting the publication of her first book. She had come back to Canada after living in Ireland and receiving her creative writing post-graduate degree in England. When she told me she had lived and studied in England, I was expecting to hear a poetry that struck an English note—the Hardy lyric that infiltrates so much of British verse. Instead, I encountered a poet whose work was very much in the Livesay tradition—the brief, almost imagistic lyric that is filled with spareness of language and echoes of Eastern art.

I ran into Catherine again at one of Anna Yin's gala poetry events in Toronto in the spring of 2015 and at the IFOA's Battle of the Bards at Harbourfront (she had won the competition the previous year) and invited her to come to Barrie. She is friends with Kate Marshall Flaherty and Kateri Lanthier, and they all arrived within an hour or two of each other and met up on the Lakeshore trail that forms a horseshoe around Barrie's Kempenfelt Bay. It was a beautiful day, and Catherine said that she had been inspired by the experience.

What resides at the core of her poetry, and what she teaches her students—she is a very active teacher and is one of the instructors in the Creative Writing Program at the School of Continuing Studies at the University of Toronto—is that poetry is driven not by subject or even form, but by the eye. Teach a student to see and they will learn to write, a maxim that I practice with my students.

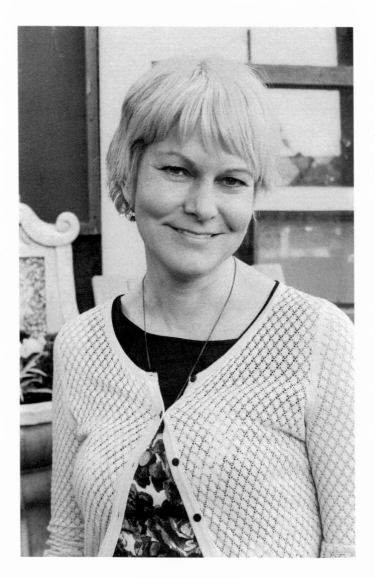

CATHERINE GRAHAM

➤ **James Grainger** came to speak to the students in the program I was teaching at Georgian College in Barrie. At the time, he was the review editor of *Quill and Quire*, Canada's publishing magazine that serves as one of the most influential sources for up-to-date critical feedback on new writing, a job that used to be done by most of Canada's daily newspapers before review space was eaten up by other concerns. He spoke to my students about what it takes to become a writer in Canada. One of them asked him what he had published in book form. He smiled and said he was working on something.

That something became Grainger's most recent novel, *Harmless*, a narrative about a group of old friends who get together at a country house only to have everything go awry as a result of old animosities, 'pressures, and erotic tensions'. This Canadian take on the old 'ship of fools' motif that is popular in Irish great-house literature suddenly becomes a wilderness gothic narrative when the daughters of two of the friends go missing in the woods—the woodland labyrinth that haunts the Canadian imagination.

When I heard Grainger had a novel about to appear, I emailed him and asked him to come to Barrie to give a reading. No one had asked him to read, and he gave his first public reading from the work literally hours after the book appeared in print. He gave me one of the first copies of the press run. I photographed him shortly before the reading, where he shared the evening card with Kateri Lanthier, Kate Marshall Flaherty and Catherine Graham. We sat on the patio of the Unity Market Cafe where the monthly reading series in Barrie is held. That evening was the end of the first warm day of spring, and the warm sunshine on Grainger's face appears to please him.

JAMES GRAINGER

⤳ **Richard Greene** is a master of the exquisite art of polished erudition. Long before I met him and we became friends, Richard's book *Dante's House* had caught my eye not only for the fact that it had won the Governor General's Award, but for the fact that a significant portion of the book was written in Dantean *terza rima*, the Italian verse form of falling forward in a continuous journey.

I photographed Richard in Linares, Mexico, while I was there for a writers' conference organized by his former student Colin Carberry. As a fellow poet, there is little I can say about his work in the way of superlatives that has not already been said, but as friend, someone whose feedback and ideas have been a tremendous help to me, he is one of the rare, truly generous individuals who loves the art for its own sake.

Originally from Newfoundland, Richard possesses a dry wit and a powerful sense of storytelling. We found ourselves out for a long walk in the burning afternoon Mexican sun one day, telling stories to each other and meandering through the streets of the old colonial capital of Nuevo Leon, when we realized that neither of us had a hat. By chance, there was a labyrinthine market nearby crammed with stalls of vendors—most of them at home for their siesta—and in one stall I bought a varnished planter's hat. Richard chose a New York Yankees ball cap. It turned out he was a devotee of the 'Bronx Bombers' and went to see them play whenever he was in New York.

The picture was taken in the shadow of the ancient cathedral of Linares, on the north side of the church, where we had gone to find shade while we figured out where we had ended up in the course of our peregrinations through the old city.

RICHARD GREENE

Ralph Gustafson was one of the most elegant poets I have met. A concert pianist—his next door neighbour, D.G. Jones, remarked that he heard Ralph's piano more than he saw him—Gustafson was very happy to be photographed. This portrait was not taken in his hometown of North Hatley, Quebec, in the house where the League of Canadian Poets had been founded one summer afternoon, but in Toronto, on the balcony of a hotel suite on Sherbourne Street where Ralph and his wife, Betty, were staying during their visit.

Ralph explained to me, very earnestly, that authors needed to be photographed because a lasting and continuous record of Canada's writers was constantly being interrupted by the loss of the country's best portrait photographers. He told me that Yousuf Karsh, the photographer who took iconic portraits of major figures such as Winston Churchill, had apprenticed in Sherbrooke, Quebec, at Ralph's father's photography studio.

For Gustafson, a poem had to be music. Words such as 'sonata' and 'symphony' fill his books. He believed that a poem had to possess a sense of resolution, just as a musical score needed to reach a 'perfectly rounded and conclusive ending, or an essential pattern of nature is lost.'

Gustafson said that he wasn't sorry he and his wife had not had children. 'My books have been my children.' He had a watch fob made of the cover of each of his books. O'Riordan and I interviewed Gustafson in the spring of 1989, but the interview has never been published, and much of Gustafson's best work remains ignored by critics and contemporary readers. That is a shame, because every time I read one of his poems, I can hear his piano, just as D.G. Jones did, somewhere in the distance.

RALPH GUSTAFSON

~★ **Richard Harrison** walked up to me and introduced himself at a League of Canadian Poets party in Toronto in 1981. I had co-founded the Associate Membership of the League with James Deahl in order to engage younger members in the organization (in those days, one could not get a book published unless one was a member of the League and one could not become a member of the League unless one had a book). Richard was one of the first to sign up for the new program. We became good friends. We hung out together at the League AGM in Vancouver, and he was part of the reconnaissance party that went out to explore Wreck Beach.

Richard lived in Peterborough but made frequent visits to Toronto, where he slept on my parents' hide-a-bed in our rec room. In February 1982, he was part of a group of four poets—myself, Ross Leckie and Lawrence Hopperton—who did a tour of upstate New York to read our poetry. There we were hosted by the poet and editor Joseph Bruchac, and we visited Yaddo, where poet Robert Sward was staying.

The four of us were playing pool in a redneck bar (decorated in wasps' nests) outside of Saratoga Springs, and were getting taken by the locals on what was clearly a crooked pool table. Everything fell silent when a gang of bikers walked in. The bikers had been there before and trashed the place because the locals were outnumbered. The locals lined up with four Canadian poets, and we stared down the bikers, who beat a quick retreat. We didn't have to buy beer for the remainder of our weeklong stay at the Bruchacs.

Richard now lives in Alberta and teaches at a university there. His work was featured in a documentary aired on the CBC and presented by Adrienne Clarkson.

RICHARD HARRISON

Bill Humber, Canada's foremost baseball historian and an aficionado of the history of just about every other sport, was on our honeymoon with my wife and me. When we married in 1994, I was working on a collection of baseball stories that included research into the first baseball stadium in Toronto—a mythical stadium that I eventually proved had existed although the city had no photographic records of the place among the thousands of images in the civic archives. The stadium had the iconic name Sunlight Park.

An historian of the Don Valley, Charles Sauriol, had told me it would be virtually impossible to prove that the stadium had been real even though the first Canadian professional sports championship had been won there in 1884 on the arm of a remarkable pitcher, Ned 'Cannonball' Crane. I needed to get to Cooperstown to go through their archives on the off chance that I would find something there. Bill ran a baseball tour to the Baseball Hall of Fame each June. My wife, the good sport that she is, said she would come along on the almost all-male bus tour (which was far more within our means at the time than an actual honeymoon), and agreed to help me go through the holdings of the baseball library.

Bill was gracious in that he arranged for my wife and I to have a special suite at the motor lodge where the tour stayed. During the visit I found what I was looking for—photographic evidence of the stadium. I wrote an essay on Sunlight Park for a baseball history book that Bill published, as well as a fictional account of the grounds. My work was cited on a plaque about Sunlight Park that was located for many years on Queen Street.

BILL HUMBER

Bruce Hunter, a hardy Calgarian by birth and background, has spent most of his professional life in the Toronto area. He was present at Laurence Hutchman's wedding, as a guest like me. As is the case with Laurence Hutchman, Bruce and I have known each other for an eternity. He was a frequent reader at the Main Street Library readings in the seventies, a series in the library basement in the east end of Toronto that was frequented by Dorothy Livesay and Milton Acorn. Bruce was also a regular open-mic reader at the Axle Tree Coffee House series around the same time.

Bruce writes with an earthiness and a passion for narrative. A natural storyteller, his work asks that a reader listen, not merely to what he says but how he says it. His language is graceful and beautiful without compromising the rugged vitality that is the hallmark of his novels and verse.

While we sat in the garden at Laurence Hutchman's and enjoyed the food, the weather, and the frantic mother robin over our shoulders, we talked about the debt that we, and many of the poets we knew (James Deahl among them), owed to Milton Acorn. Unlike his more public friend, Al Purdy, Acorn was a man of considerable quiet when he wasn't declaiming. It was that quiet in which he spoke to us as young poets.

Bruce had also been mentored by Irving Layton. Bruce had been a student at York University when he decided to sign up for a poetry class that Layton was offering. In the middle of one of Bruce's poems, Layton had exclaimed 'That's it!' Both Bruce Hunter and I, not just under the guise of teaching writing to college students, he at Seneca and I at Georgian, have tried to pass *it* on.

BRUCE HUNTER

Laurence Hutchman has been a friend and a fine fellow poet since we met at a Black Moss anniversary reading in 1989. We had both grown up in North York, he in the west end in an area known as Emory, and I in the central corridor of Willowdale at a crossroads that had once been known as Oriole. Both Emory and Oriole are long gone. They have been absorbed in the megalopolis of the Greater Toronto Area. At the time we met, we were both deep into a search for the stories and the pasts that had been part of where we had grown up. I had tried to write about Oriole, one of the birthplaces of the 1837 Rebellion—an uncle of mine had owned Joseph Sheppard's store that once stood at the intersection of Yonge and Sheppard, and even had a manuscript of poems about the place accepted for publication. Alas, the publisher went bankrupt. Hutchman, however, did not abandon his pursuit.

There is a strong desire shared by some Canadian poets to try to find a past in the place where they live. For some, it means delving into personal and ancestral mythology, while for others the search involves painstaking research. The element of research has been the hallmark of Hutchman's poetry. For him, Emory is as much a place where the past lives as does the present. He refuses to believe that past and present are separable, and sees the intertwining of times, faces, stories, and traditions in the present.

I photographed Laurence in his garden on the day of his wedding to Eva Kolacz, a Polish artist. The two were wed on a perfect, late-spring day. As I was photographing him, a mother robin was feeding her nest of chicks at the junction of the eavestrough downspout and the wall of the house. The flowering shrubs around the yard were in full bloom.

LAURENCE HUTCHMAN

Luciano Iacobelli is a familiar face and a motivating spirit on the Toronto literary scene. A poet of considerable talent, Luc is also co-publisher of Quattro Editions, and in his spare time he hand-sews small, limited-edition hardcover chapbooks by Toronto poets in the LyricalMyrical editions. I am proud to say that Luc has published three of my chapbooks under the LyricalMyrical imprint: *As Yet Untitled* (2005), *Bread* (2010), and *A Litany of the Makers* (2014). The chapbooks were made by ripping the front and back covers off books that Goodwill wanted to recycle (but could not because of the boards), and printed in editions of fifty to sixty. The launch of a new set of LyricalMyrical books is a social event, usually held at venues such as the Gladstone Hotel or the Village Oven in Toronto's Little Italy district. The books sell out within an hour, making them both precious and very limited. Friends have asked me if I had extra copies for them, to which I have responded, 'Sorry, but you had to be there.'

Luc believes that books should be made objects, that the publisher is not merely a producer of books but a craftsman, and that each book should be unique. I asked him when he finds time to do the hand-sewing of each volume—and at most of the LyricalMyrical parties where the books sell out there are hundreds of the volumes stacked neatly, bound with book tape, and with an overpasted image on the front cover. 'I do it while I watch television.' He reminded me that making a book by hand is not merely a publisher's art but something very close to shoe-making, where each stitch is pulled, knotted, and tied. Every volume is numbered. I have a small collection—far from a complete collection of LyricalMyrical chapbooks. He has published everything from a translation of *Antigone* to a miniature novel. The books are works of art, unique to Toronto.

LUCIANO IACOBELLI

➤ **Daniel Jones** went by the name **Jones**. He was an enigmatic figure on the Toronto literary scene, a modern-day rake whose poetry and life were both brilliant and self-destructive. I first met him before he became a noted presence in poetry when we were both in undergraduate classes together at Victoria College. His early work was wild, undisciplined, and highly irreverent. After several years of intensive undergraduate work, I lost track of Jones. He turned up in some of my sister's classes, and she remembers him because he came to class one day with a bag of rotting onions and was ordered by the professor to remove them. Jones got up, left, and didn't return to the class for the remainder of the term.

He published one book of poetry in his lifetime (though I suspect that his output was more prodigious than a single volume), *The Brave Never Write Poetry.* I liked his book and gave it a good review in one of the literary magazines. Jones wrote to me and asked if we could keep in touch. We did. He sent me a postcard to say that he had hitchhiked in a drunken stupor all the way to Mexico where he had a crap in the ocean, and wrote about it. I published the poem in what was the first anthology of Canadian poetry to be published in the United States, *Arrivals: Canadian Poetry in the Eighties.*

This photograph of Jones was taken on the same day as James Deahl's, at Grossman's Tavern on Spadina Avenue in Toronto. Jones seemed very remote, almost shy and withdrawn, that afternoon. That was the last time I saw him. Several years passed and I wondered if he was still writing. He possessed a Rimbaudian talent, and a Rimbaudian personality that led him to self-destruction and eventually suicide.

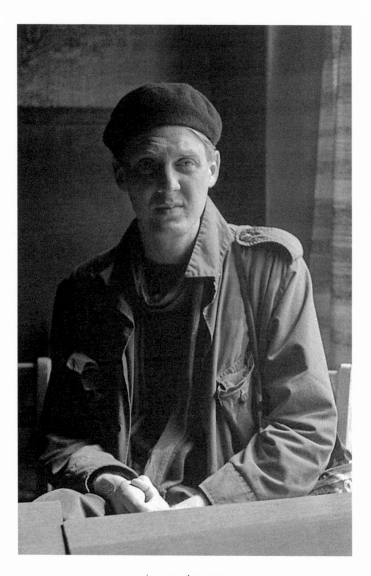

(DANIEL) JONES

The late **D.G. Jones**, Doug to those who knew him, may have been one of the most influential voices in Canadian poetry, not just for his verse but for his criticism. He was author of *Butterfly on Rock*, a work of literary criticism that deserves to be reissued. In that book, the bilingual Jones argued that French-Canadian literature focuses on being lost in a wilderness of time whereas Anglo-Canadian literature is concerned with being lost in a wilderness of space. Our poetry, he suggested, is about how we deal with those puzzles.

As a poet, Doug Jones was a miniaturist, a craftsman of the almost oriental-short line that reads with precision and a selected and exacting power. I photographed Doug in the garden of his home in North Hatley, Quebec, not long after he had won the Governor General's Award for *Under the Thunder the Flowers Light Up the Earth*. I wanted to capture the plethora of tiny spring blossoms that surrounded him as shadows through the trees dappled his sculpted features.

During the interview, as had been the case with Al Purdy, O'Riordan and I were not quite sure what we were getting, let alone what he was saying. After we turned off the tape recorder, he took us on a high-speed motor tour of North Hatley, pointing out where Hugh MacLennan and F.R. Scott had had their cottages, and where Montreal Canadiens GM Sam Pollock lived part of the year. He passed a house and waved to a lady. 'I wonder who she is?' he asked. 'Your wife,' we said.

North Hatley may have been the closest Canada has come to having its own version of Concord, Massachusetts, a place where writers lived and worked together.

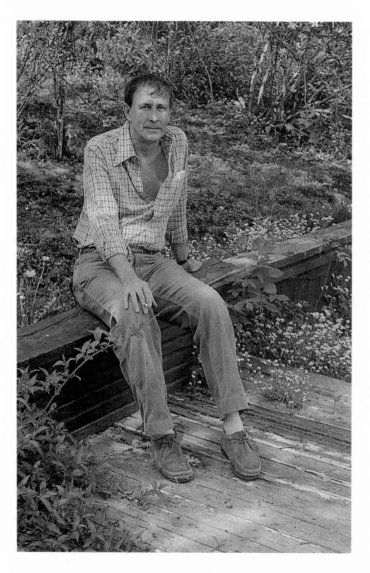

D.G. JONES

In 1983, **Joy Kogawa** had just published her acclaimed novel *Obasan*, a work of artistic beauty and historical accuracy that led to the Canadian government's apology and reparations to the Canadian-Japanese community for the treatment they had received during World War II. Based in part on manuscripts she had found in archives, and in part on her family's experience during the forced relocation, Kogawa brought the plight of her community to life with tremendous empathy in one of the most moving novels written by a Canadian.

This photograph of Joy Kogawa was taken at her home in the north end of Toronto's Little Italy district. When we arrived, she showed us a board game she had been given as a child, The Yellow Menace. It was a snakes-and-ladders type of game about beating the Japanese. We sat on tatami mats throughout the interview. What caught my eye as I looked through the viewfinder was the exquisite Japanese vase in the background, an object that is almost a shadow behind her.

Never one to shy away from confronting difficult issues and matters, Kogawa has served not only as an imaginative force for Japanese Canadians, but as someone engaged in Canadian politics and literature. Early in her career, she served on the staff of Prime Minister Pierre Elliott Trudeau; but her focus has been the passionate art of words, and deserves to be celebrated not just for her outstanding novel, but for her poetry and her children's books. Shy and self-effacing, she is often the last person to admit the full scope and powerful impact that her work has had on Canadian culture, society and history.

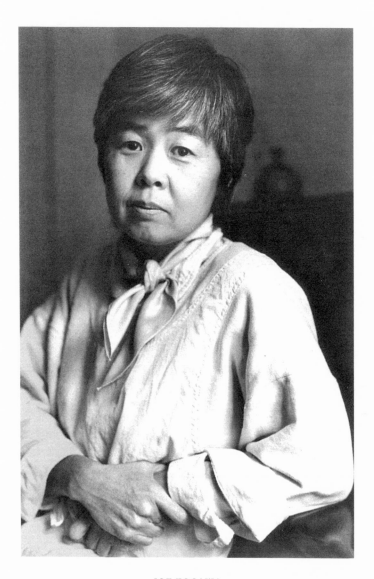

JOY KOGAWA

O'Riordan and I travelled to Saskatoon to interview **Patrick Lane** in the winter of 1983. From atop the hotel where we were staying, we could look across the snow-covered plains that ran north from the city. This photograph of Patrick was taken beside the South Saskatchewan River, which bisects the town. It seemed appropriate that a poet who has written so poignantly of the hardness of life in Canada—not just the economic toughness and edge but the spiritual forces that test our resolve to be who we are—should have worn a parka to the shoot.

During the interview, Patrick talked about the various jobs he had over the years, the hard work that had gone into supporting himself so that he could write poetry. That hard work, the far-from-easy life, is the reality behind this country's literature, and Patrick Lane captures that in his poetry. There is nothing easy about what he writes, yet it is a hardship that seems so familiar.

He reminded us that this a country where the working people put down their roots only temporarily in order to work as miners or lumbermen, and then, when the resource is exhausted, move on to another place. Patrick had decided to go back to his childhood home. He recalled that his mother would get angry at him and his brother 'Red' Stanley Lane (a fabled poet of the early sixties who died far too young and who had been a friend of George Bowering and Al Purdy) when the boys swung from the rotating splayed-arm clothes pole— the kind that were ubiquitous in the fifties and sixties. He returned to the place where their house had stood—the street was still there, and he could even trace the outline of the house. The one thing that was still standing was the clothes pole.

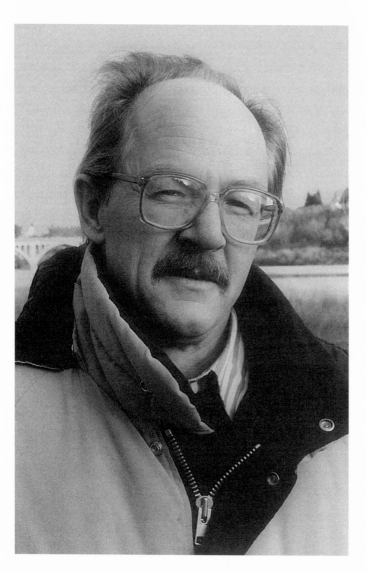

PATRICK LANE

Kateri Lanthier and I met when she was an undergraduate at the University of Toronto and I was a master's student. She impressed me with her poetry which was, at that time, still in its nascent stages. I visited her at her parents' house. The walls were hung with paintings by William Kurelek, the Prairie artist who now commands a respected place in Canada's galleries. They were paintings of people celebrating important moments in their lives, a happiness that was overmasked by an inexplicable sadness, yet shone with a delight in the world. That spirit in Kurelek appears to have shaped the work of the mature poet that Kateri has become. She is, to me, the Mrs Dalloway of contemporary Canadian poetry, someone who takes delight in the commonplace discoveries of life, yet who expresses an empathy for what she sees.

We had not met in over thirty years when Anna Yin invited us to read together at one of Anna's mini-festivals in Toronto. I invited Kateri to come to Barrie for a reading, and that is where I photographed her in July 2015. There was a sadness in her early poetry (many young poets are sad and do it better than older poets), but in Kateri's case the Dudek rule (to be a poet at twenty is to be twenty, but to be a poet at forty is to be a poet) holds true for Kateri. Her poetry is a poetry of insight and delight, a celebration of the small but no less important things that make life worth discovering.

Between sets, we talked about our children, what they do, what they want to do, and how our lives pointed us in different yet parallel directions. She, too, has become a teacher of writing, and she passes the wisdom of accumulated poetic and life experience to her students.

KATERI LANTHIER

⤳ Ralph Gustafson wrote a very short poem about **Irving Layton**: 'Oyving's/Unoyving'. That only sums up a small aspect of a man who was larger than life, whose poetry roared and often shook the foundations of Anglo-Canadian society, and who was one of the most artistically committed poets I have known. He was a teacher of Creative Writing at York University, and many of my poet and writer friends who passed through there owe their vocations to him.

I got to know Irving Layton when he was writer-in-residence at the University of Toronto in the early eighties. It was the interview with Layton that set Brian O'Riordan and I on our long journey through Canadian literature. Irving liked what we did when we interviewed him: we put his poems first and his press clippings second, and based our questions on that. He gave us Leonard Cohen's telephone number (and Cohen's flat in Montreal was adorned with images of Layton—his mentor and his literary father figure), and that led to the two books of interviews we did and immersed me in this country's literature. I owe a great deal to Irving Layton.

In person, Layton was playful, a man with a tremendous sense of humour that could become passion and even anger in an instant. He did not hide his emotions. When he got angry, his eyes would darken. When he laughed, he would throw back his head and roar. This photograph was taken while Layton was living in Port Credit, Ontario. I wanted to capture the mane of the lion, the light and darkness that inhabited his features, and the fist of the boxer he had been in his youth. His poetry is read today, long after his death, because when he was good there was no one of his generation who was his equal.

IRVING LAYTON

Max Layton is almost entirely different from his father except in one respect: he is a fine poet. I had the pleasure to get to know Max when he emailed me out of the blue to ask about French forms in poetry—something that has fascinated me since my time in the late eighties and early nineties when I was involved with the American New Formalist movement. After I'd given Max some hints about how things such as villanelles worked, he sent me one. 'Like this?' It was a brilliant villanelle about 9/11.

Max should not be compared to his father. Max is a singer, a very easygoing soul whose poetry is delicate, loving, and kind. Music fills his lines. He performs frequently with Robert Priest, and he writes much of his own material.

This photograph of Max was taken when he came to give a reading in Barrie in 2015. His poetry is powerful because of its restraint, a *sotto voce* mixture of love, insight, and vision. I participated with Max in the International Festival of Authors Battle of the Bards night, and despite the fact that neither of us won, Max impressed me with the brilliance of his poems. In the audience that evening was the American poet Jared Carter, one of the great underrated masters of poetic form and voice whose own poetry shares that clarity of vision that Layton's possesses. Carter's honest opinion was that Max was the best of the evening; that said, the competition was to discover new talent, and Max and I agreed that we'd been around a long time. Bardic contests aside, Max Layton's work is very much a discovery, and credit must be given to Michael Mirolla of Guernica Editions for bringing it to light.

MAX LAYTON

➤ **Ross Leckie**'s first book of poems, *A Slow Light*, was something to celebrate when we were both young poets. Ross made up the quartet of poets that went to upstate New York in February 1982 on a tour we called '1812 Again', according to a sign that Richard Harrison scrolled in large letters and taped to the back window of Lawrence Hopperton's white K-car.

Ross loved second-hand bookstores, as did I, and we drove around the back roads of the Saratoga area in search of a fabled bookstore that we did not find until it was almost closing time and sunset. We both rushed to the poetry section. The books were selling for next to nothing, and each of us filled two cartons, though in a rush we had bought double copies of some books—neither of us had purchased the same doubles though, so we sat on Joe Bruchac's living room floor and traded them as if they were playing cards.

When the British poet Charles Tomlinson came to Canada and stayed at my parents' house (Charles and his wife, Brenda, were friends of my parents), Ross hosted a talk at the University of Toronto that Charles gave (I was still a graduate student at McMaster at the time). We gathered with Al Moritz, Michael Kirkham and Jeff Lindsey at Jeffery Donaldson's flat on Spadina Avenue. I have not seen Ross since. He took a teaching position in Prince George and eventually moved to New Brunswick, where he has been a force at the UNB as head of the prodigious Creative Writing program there.

I have sent many of my students to study with Ross. Whenever they go, I ask them to ask him about his Noam Chomsky poem from *A Slow Light*. Ross used to read the poem in Chomsky's voice. They write back and tell me it was great.

ROSS LECKIE

꘏ My introduction to **Carole Leckner** and her poetry was at Black Moss Press's twenty-fifth-anniversary reading at Harbourfront. I had just signed on to the press for my first book of poetry in 1989 (courtesy of the efforts of Gwendolyn MacEwen to get my work into print). Artist Barbara Klunder did a stunning poster for the event that featured twenty-five Black Moss authors as various animals of the mythic and zoological variety (I was a horse leaping out of the gate). There were some poets at the event whose work didn't speak to me for whatever reason, but following the reading I walked up to Carole and told her I liked her poetry. Our paths did not cross again for the next seven years.

When I was asked to establish a creative writing program for the University of Toronto's School of Continuing Studies, I was surprised to learn that Carole was already part of the school's cadre of instructors, and was teaching a course in the Liberal Studies program on Creativity Theory. I asked her if she would be willing to come over to the fledgling Creative Writing Program, and that is when I photographed her at her apartment in Toronto in 1996.

The photographs I took of that first group of author/instructors were intended for marketing purposes (even though I paid for the film, developing, and printing of the original pictures). The author portraits appeared in the brochure that the School of Continuing Studies produced to promote the program, and on bookmarks that the authors and I handed out at Word on the Street. To my surprise, the bookmarks started circulating among the kids who had shown up at the event and became a hit—literary Pokémon cards. I watched, amused and delighted, as two ten-year-old boys stood in front of the program's table on Queen Street and traded with each other to complete their sets. Olive Senior got swapped for Carole Leckner. Carole liked that.

CAROLE LECKNER

When **Dennis Lee** was writer-in-residence at the University of Toronto during my undergraduate years, I went to him with my poetry and he did not like it. He named off several poets and told me I should write like them. The old cliché that a person only has one chance to make a good first impression holds true in this case. My poetry was archaic, too artificial, and not really about anything. I don't think Lee realized that my passion was to write and that I not only *wanted* to learn something but that I *needed* to learn something. About the same time, my professor Jay Macpherson turned her Friday class in Romantic Poetry into a seminar-style workshop on prosody, and my writing changed drastically. What young writers often need, more than anything, is someone to teach them what they may not know, may not see, and may not recognize that they can do.

Lee has been one of the most influential figures in Canadian literature, and I wonder if my struggles today to break into the inner circles of CanLit can be traced back to that bad first meeting. We are still on good terms—good enough, in fact, for him to stop and talk to me in the lobby of the Harbour Castle Hotel during an International Authors Festival years later and invite me to come along for a meeting he was having with the Lebanese poet Adonis, who I also photographed at the same time.

The Dennis Lee that most Canadians know is the creative genius behind a number of children's books and television programs, and his book *Civil Elegies* remains one of the seminal works not only of Canadian poetry but of Canadian criticism. In that work, he points a distrustful finger at old Toronto puritanism. Lee saw me as someone who had been raised in that environment and I sensed he disliked that in me.

DENNIS LEE

➤ Few poets have provided as much good humour as **John B. Lee**. Straightfaced and profoundly glib, whether writing about cows or the War of 1812, John is a wonderful person to hang out with. This photograph was taken at a reading we did together in Simcoe, Ontario, an area I had not visited until I visited it with John.

We had been in Windsor with Marty Gervais to read at a gathering of Poets Laureate, and John invited me into his 'neck of the woods', and offered to drive me back. The drive to his home in Port Dover should only have taken us two hours, but instead, John took me on a tour of Canadian literature sites, 1812 battlefields, 1837 Rebellion houses, graveyards, and scenic lookouts. I was almost sorry to arrive, but his wife, Cathy, had a fine spread waiting for us.

John is not merely a poet, or even a teacher, or a teacher of poetry, but a historian of the land and the heart. I find a kindred spirit in his eye for research (he has put more research into the Talbot Trail than I have into my search for World War I Canadian literature). One of his literary heroes is the poet and short story writer Raymond Knister, who was born and raised in John B. Lee country on the north shore of Lake Erie, and who drowned while swimming in Marty Gervais country near Windsor.

For John, the past is never far away. He was born into the farm country of Norfolk County, and his poetry, far from being country verse, is a passionate opus that gathers together the experiences of a traveller who can never quite see enough of the world, whether it is Baffin Island, Central America, or the Far East. He is a natural storyteller; John and I connect at literary gatherings where we sit down, have some beers, and I listen as he regales me with stories that never cease to fascinate or enthrall.

JOHN B. LEE

⌁ Although I did not meet **Norma West Linder** until she came to Barrie with her husband, James Deahl, to give a reading in 2015, I had heard of Norma in 1981. That year, London poet and literary energizer Sheila Martindale accepted a chapbook manuscript of mine for publication by her micro-press, SWOP (Southwestern Ontario Poetry Press). The little chapbook *The Tongues Between Us* was my first foray into book-like print. I was over-the-moon happy about the process. Sheila also did chapbooks by Lawrence Hopperton and Cary Fagan. Among the authors on the SWOP list was Norma West Linder, a writer from Sarnia. Sheila gave me a copy of her book.

Years passed. I did not know what had become of Norma. Those who publish with small presses or micro-presses are often not heard of outside of their specific region. James Deahl wrote to me that his second wife, the editor and book designer Gilda Mekler, had died. I knew Jim was going through a rough time and we wrote back and forth to each other. Jim, by this time, had relocated from Hamilton to London. Then, one night, I ran into Jim at a reading. 'I've remarried. She's a woman I met in grief counselling, and we're both grief counsellors now. You may have heard of her. Norma West Linder.'

Norma and Jim now travel as far as they can drive in a day to give readings, to explore places that they write about, and to live life well. I photographed her in Barrie when she came here for a reading, and in late 2015 Jeffery Donaldson, Andrew Brooks, Lawrence Hopperton, Jim, and Norma, gave a reunion reading together in Sarnia.

NORMA WEST LINDER

Dorothy Livesay was an activist, a woman who raised her voice against the injustices of the world. She loved causes, especially human causes, where the stakes were about freedom, independence, and dignity. She was one of the toughest poets I have known, a fighter who could stand up against wrongs one minute and the next minute become a gentle, loving spirit whose poetry achieves a delicacy when she chooses to look into the quiet moments of life.

I photographed her at her alma mater, Trinity College at the University of Toronto. She was determined to have her picture taken next to the bronze roundel of one of her heroes, Archibald Lampman, that once hung in the basement library of the college. Having gotten the picture she wanted, I was able to persuade her to permit me to take the picture I wanted. I wanted a picture that would sum up that personality that was a rare mixture of fighter and lover. One hand is open, laid in her lap as gently as if it is cradling a dove. The other is clenched in a fist. That was Dorothy Livesay.

I dropped by her office at Massey College when she was writer-in-residence at the University of Toronto, and she invited me along to Hart House's Arbour Room to have beers with the acclaimed Hungarian poet George Faludy (I regret not having my camera with me that afternoon). Faludy told the story of how his poems had been smuggled out of a Soviet prison after he had been arrested and held following the 1957 Hungarian Uprising. Dorothy was inspired. After finishing several rounds, she informed everyone at the table that she had to get back to her rooms to write something. She wasn't steady on her feet, so I told her I would walk her back. As we made our way along Soldiers' Tower Lane, she stopped and French kissed me. 'Oh, if we had lived in the same time,' she said.

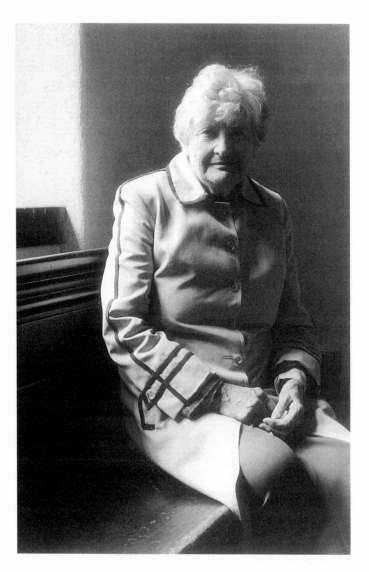

DOROTHY LIVESAY

When I moved to Barrie, I thought I would be alone as a published poet. I knew of no one there who had ventured into the world of writing and poetry books. I was heartened to learn I wasn't alone. Quammie Williams, a professional drummer from Toronto, had just been hired by the city to be Barrie's first Cultural Officer, and he had heard that I'd arrived in town. Quammie invited me to be part of a group that would establish the city's first arts council. There was no funding available for the venture, but the city wanted to see what could be done in terms of guerrilla culture. That is where I met **damian lopes**.

damian writes his name in lower case and for good reason. He is a quiet, understated, creative cultural activist, an experimental poet who crafts superb poems from the bare bones of expression. He has published several books, but for the most part his great passion has been micro-publishing. The arts council did some good things, but after the initial group left, the effort appeared to lose energy though it still continues. What we were able to do, at least, was to get various arts communities to talk with one another, to cross-pollinate events so that wherever people gathered for one form of art they would be exposed to others.

In 2014 damian succeeded me as Poet Laureate for the city. He writes slowly and carefully—everything from a novel in progress that touches on his African roots to translations from the culture of his deep past, India. He brought the Barrie Arts Awards gala audience to tears in November 2015 with a poem about his experiences in Paris, dedicated to the victims of the Paris nightclub bombings. I photographed him outside City Hall in downtown Barrie as we were preparing to do an evening of advice for new writers.

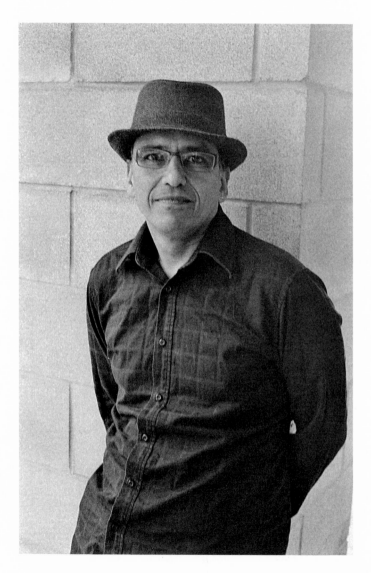

DAMIAN LOPES

~✺ When I photographed **Gwendolyn MacEwen**, I wanted to capture her eyes. To have known her, to have looked into those eyes as she talked about T.E. Lawrence or the mysteries of Egypt was to be reminded of the eyes that were painted on ancient Greek ships. She had a rare classical quality about her. When she presented her work in public, she would fold her hands in front of her, stand with her chin raised and her voice clear, and recite. She never had a note in front of her. She was, in the very truest sense of the word, a rhapsode, a singer of her own songs.

I would meet her as she rode her bicycle with its tiny wheels along the streets of the Annex near the University of Toronto. She would call to me and ask me to join her for tea. The front room of her house had a raised seating area lined with kilim cushions. The window was festooned in hanging plants. We would talk about poetry. She taught me a great deal about the art. One day she turned to me and said, 'You are the son Milton Acorn and I would have had.' We burst out laughing, but it was a comment that I still treasure.

I didn't know it at the time, but she read my poetry. She told me how much she liked it. Unbeknownst to me, the manuscript of my first book of poems, which had been rejected by over six hundred publishers all over North America, landed on her desk (courtesy of James Deahl, who went to visit her when she was writer-in-residence at the University of Toronto). She telephoned me on the final Boxing Day of her life (though, at the time, I didn't know how ill she was). She told me she loved the manuscript and was sending it to Marty Gervais at Black Moss Press. The following October, a week after she died, I received the acceptance letter for my first book of poems. It is dedicated to her.

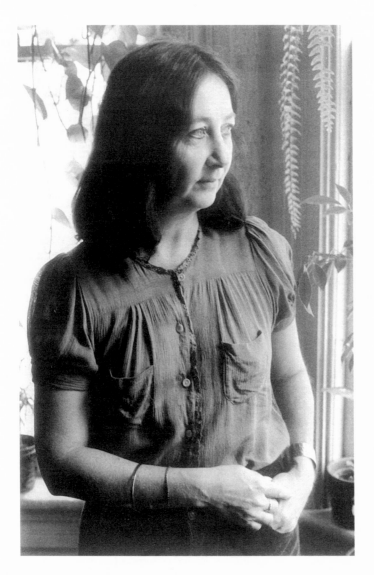

GWENDOLYN MACEWEN

⤳ **Alistair MacLeod** and I met electronically long before the digital age had come into being. I was asked by James Deahl, who at the time was producing a television series, *The Academy on Canadian Literature*, for TV Ontario, to be the 'authority' on air for the episode that focused on Alistair (Al) MacLeod. At the same time, I met Sandra Martin, who was hosting the series. The interview with Sandra in which I discussed MacLeod's work aired in repeats for almost twenty years.

At the time I did the TV Ontario show on MacLeod, he had only produced one book. The day after the episode aired, I received a wonderful handwritten letter from Al, who said that if I ever came to Windsor I should look him up. He was a professor at the university there. Five years later, O'Riordan and I interviewed Al, and he took us on a tour of the University of Windsor campus. In this photograph, he is sitting on the stairs in Dillon Hall, the oldest academic building on the campus. The scrolls in the banister are symbolic of the waves of the oceans.

When he won the Dublin IMPAC Award, among the richest fiction prizes in the world, his reputation as one of the finest writers Canada has produced was solidified. When I taught for a year at the University of Windsor, Al and I did a class together on Canadian short fiction. The class had over three hundred students in a large lecture hall. He decided we should split the two-hour lecture fifty-fifty, and true to his word, at exactly the halfway point, he would start up the centre aisle and I would start down the centre aisle from my seat at the back and pick up the discussion, sometimes mid-sentence. When I lived in Windsor, Al would often pick me up and we'd go over to Detroit for Mexican food.

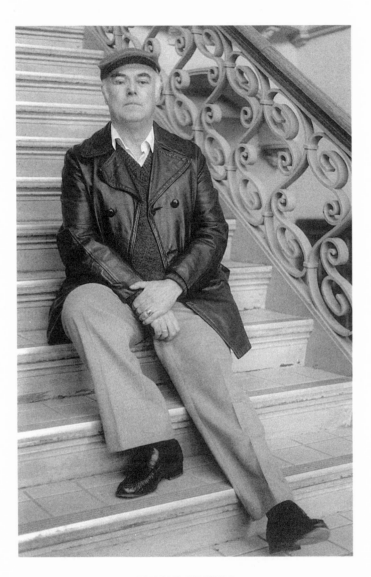

ALISTAIR MACLEOD

⤳ Poetry is alive and well in Edmonton because of **Alice Major** who was a former Poet Laureate of the city. I first met her in Edmonton during the poetry festival there, an outstanding event organized by Rayanne Doucet. The weeklong celebration of poetry brought together civic laureates from across Canada, and the Makar (Poet Laureate) of Scotland, Liz Lochhead. Liz and I had just done an event at radio station CKUA's studios with Alice when we were walking back to the hotel and a dust storm darkened the streets with grit and even small airborne pebbles. Liz motioned me into a doorway and wrapped us both in her woollen shawl. I almost got tossed out from under the shawl when I remarked 'I never thought this was how I would meet my "Maker".'

The next day was far better. Spring suddenly arrived in Edmonton and Alice gathered the poets together for drinks at the old railway hotel in the downtown. I was fortunate to sit next to Alice and we chatted about our Scottish roots—hers much closer to the old country than mine—and our experiences growing up in Toronto. That evening, we were all part of a large event at the Citadel Theatre, an event known as the Poetry Map of Canada, where poets from coast to coast read their poems. We also did a panel discussion in the rotunda of the City Hall. What I learned during that event was that most cities in Canada love the idea of poetry and the arts as a omnipresent part of civic life—an idea that I brought home to my own city, where arts funding had been savaged in favour of repainting park benches. The next October, Alice and I met up again when Marty Gervais hosted Canada's laureates in Windsor for another full-house reading. Always charming and gracious, her poetry often bridges the complexities of science with the imagination.

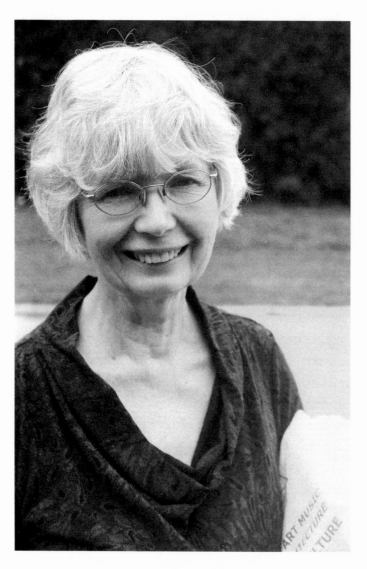

ALICE MAJOR

⤳ I returned to **Eli Mandel**'s house when summer arrived in 1982 because the photos I had taken in the attic study of his North Toronto home had not turned out as I had wished. On a sunlit spring day, we went out to his garden and there, propped against some bushes, was the original screen back door of his 1920s vintage house. The opportunity was too good to let slip away. In his poetry book *Out of Place*, Mandel had returned to his family's Saskatchewan farm to photograph and to write about the idea of displacement and otherness that was a major theme in his poetry and criticism. At the fence-line of his family farm, someone had filled a gap in the barbed wire with an old screen door, a door from nowhere into nowhere. I asked Eli to stand beside his Toronto back door and he got the connection immediately. He liked the photograph so much that it appeared on the jacket of his book about the interconnectedness of Canada's poets and poetry, *A Family Romance*.

Eli was a generous teacher of poetry and literature at York University. Throughout his life, he said he had been pursued by strange coincidences. While visiting Banff one summer with his children, he had been lazing beside the swimming pool on a hot afternoon when a man, his exact double, waved to him from the other side. Mandel said that for some, seeing one's doppelgänger meant imminent death, but for him, in the Jewish tradition that he took very seriously, it meant the onset of prophecy. This happened at the time when Layton was suggesting that he was a Jewish Messiah. Mandel looked at me, winked, and said, 'I thought to myself, take that, Irving!'

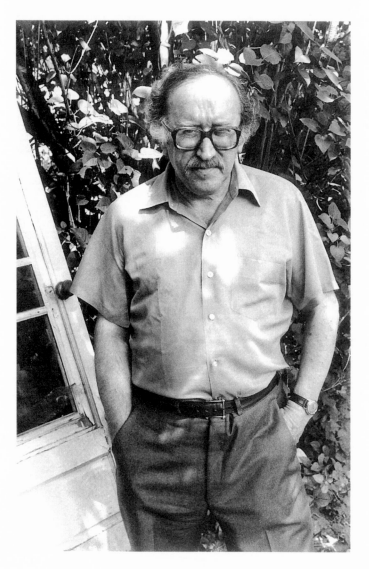

ELI MANDEL

❨ **Michael Mirolla** gave one of my early books a good review in a Montreal paper, and I was so pleased with the detail and the care he put into the review that I wrote and thanked him. I had been advised against ever contacting a critic of my work by a mentor, the literary critic and historian Paul Fussell, who called such a move an ABM—Author's Big Mistake. Mirolla's response to my response to his review was a risk I was willing to take.

Michael is the publisher of Guernica Editions, a supporter of new and established writers, and in his own right a brilliant poet and novelist. He brings to all those things a very astute mind, a depth of thought, and a love of language. When he took on the role of editor at Guernica, I sent him a poetry manuscript, which he promptly returned, but he asked me for a book of short stories, if I had any. I did. He is now my publisher.

I photographed Michael when he came to Barrie to give a reading of a short story of his that was included in Exile Edition's *Canada Noir* anthology. I am not sure that the audience in Barrie knew what noir fiction was. They missed a good show. The readers ended up reading to each other. Unfazed by the lack of turnout to the well-promoted event, Michael agreed to be photographed by me.

He returned to Barrie, undaunted, several months later for another reading. This time he was reading from his own poetry and short stories. The place was packed. Shortly before the reading began, he told me that on the way to Barrie he had received a telephone call that his mother had passed away. I asked him if he wanted to continue. He did. He gave an even better reading that evening. Michael is a writer who possesses courage as well as talent.

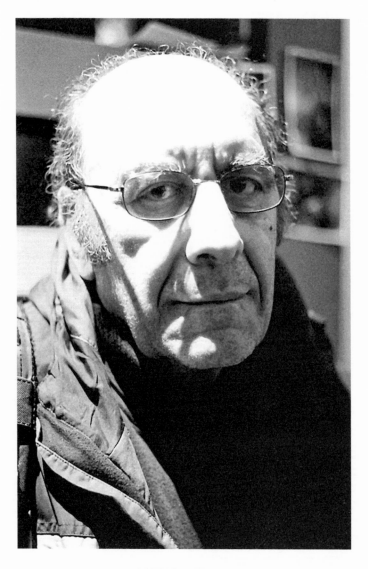

MICHAEL MIROLLA

➤ 'Be ruthless. That's what a writer has to do.' I was puzzled by what **Brian Moore** said during the interview O'Riordan and I did with him when he was writer-in-residence at the University of Toronto. I queried him on the statement. Did he mean ruthless as a self-editor or ruthless with choice of subject matter? 'No,' Moore replied. 'Steal everything you can from life—the people you know, the experiences you've shared with them. That's yours to do with as you please.' That was when I learned one of the first principles of fiction writing. Be ruthless, just as Moore suggested.

I didn't realize just what Moore meant until I interviewed the British journalist, poet, and art critic James Fenton—he who had penned the English lyrics to *Les Misérables* and become a wealthy man, and who, as a journalist, had been on the first Viet Cong tank to enter Saigon in 1974. I asked James if he wanted to see a transcript of the conversation before I published it. 'Absolutely not! I said it. You heard it. You use it even if I didn't like what I said. It is your duty to be ruthless!'

I appreciated the connection between Fenton and Moore in that moment. Moore had landed in Canada, and like the protagonist of his early novel, the Irishman Ginger Coffey, had become a journalist. The eye and the idea of ruthless theft of reality is one of the hallmarks of Moore's fiction. Nowhere is this more evident than in his account of the FLQ October Crisis of 1970, *A Revolution Script*, where Moore cited conversations he had had with the kidnappers of James Cross and Pierre Laporte. There is the powerful sense in Moore's writing that he left nothing off the table, and his sense of reportage remains the engaging element in his work, long after his passing.

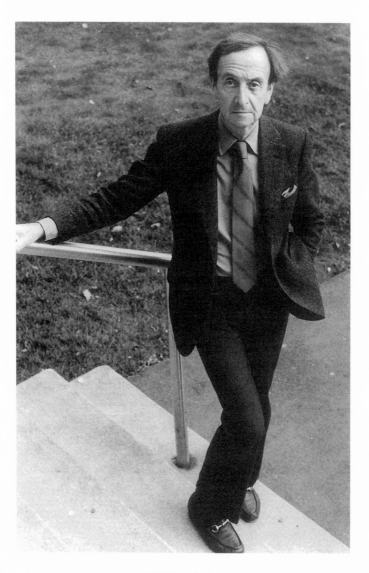

BRIAN MOORE

≫ Brian O'Riordan and I interviewed **Erin Mouré** in Montreal. She had won the Governor General's Award for Poetry a few years prior to our conversation and had just published *Furious*. I found her work challenging and intriguing. We had breakfasted together at the Vancouver Airport while we were waiting for our flight to Toronto in 1983. Personable and brilliant, she is always one step ahead of everyone. Her poems ask that the reader be prepared to work, but the rewards for that effort are great.

We asked what she meant by 'furious', and she defined it as intensity rather than language. In Mouré's work, intensity is not merely in action but in language. She continually takes ideas apart, studies how they were put together, examines phrases and what people take from what is said. Her passion for language is almost like that of a coroner for forensic detail. She is always attempting to determine causality. Such a poetics makes demands on the reader, and yet, for her, poetry is the art that has a right to press its own limits, question what words can do and why some have undiscovered purposes.

Born in Calgary and raised in Vancouver, Mouré lived in Montreal in a storefront apartment when O'Riordan and I interviewed her and this photograph was taken. I wanted to capture that element in both her work and her personality that challenges assumptions, not in a confrontational way but in an inquisitive fashion. She is smiling, what Kenneth Clark called 'the smile of reason'. In this regard, I think of her as a poetic philosophe, a lover not of arguments in the angry sense but of arguments in the philosophical and rational sense. For as many years as I have known Erin, she has never ceased to be a voice of enquiry and logic, and that is where the challenge resides. Poetry likes to defy logic.

ERIN MOURÉ

⤙ I met **John Newlove** in the late seventies in the Lieutenant Governor's suite at Queen's Park. He was one of the star guests at a gathering of former writers-in-residence from the University of Toronto. I was standing with a drink in my hand, talking to Margaret Atwood (who I had just met) and my professor Northrop Frye, when W.O. Mitchell arrived and promptly passed out. 'Get him out of here,' Frye commanded, pointing to the collapsed Mitchell. 'If the Lieutenant Governor sees him down like that it will be game over for future events like this.' Frye motioned to a bearded man in jeans and a denim shirt and added 'Help him, Bruce.' The man took Mitchell under the upper body, and I grabbed Mitchell's legs. The denim man slid his right hand out between Mitchell's arm and body and said, 'Hello, I'm John Newlove.' We carried Mitchell to the cloakroom, laid him down with a coat pillowed under this head, and covered him in someone's raincoat.

In the following weeks, when I went on my lunch-hour jaunts to David Mason's bookshop on Church Street, David invited me to join him and Newlove in the back room and we sat and talked literature (I used to spend my lunch money on first editions). Twelve years later, O'Riordan and I went to Ottawa to interview Newlove in his office in the Official Languages Bureau, where he sat and wrote poetry most of the day. His answers were almost inaudible. He was shy, not the loquacious personality I had known before, and he was dressed in a cream-coloured suit. He looked good. When we transcribed the tapes, we realized that Newlove had given brilliant answers. I told him one of his poems reminded me of Rilke's *Duino Elegies*. 'That's the nicest thing anyone has said to me,' he answered, beaming.

JOHN NEWLOVE

He has been called 'one of Canada's most prolific poets', and no one can argue with that. When Brian O'Riordan and I were in Montreal to do our second book of interviews, **Ken Norris** was very high on our list. Ken was one of the Vehicle poets, a generation of Montreal poets who were upsetting the apple carts of Canadian poetry and writing poetry that was supercharged with a desire to create a new and unique voice out of the Montreal experience. Ken agreed to sit for us to discuss his work, and I photographed him on the fire escape behind his Montreal second-floor apartment in 1989.

The interview was snapped up by *Quarry*, a literary magazine of the day that was one of the major forums for poetry and interviews with poets (my sister, Dr Carolyn Meyer, and I edited a special British /Irish issue of *Quarry* titled 'Separate Islands' around the time that O'Riordan and I spoke to Ken Norris). We sat at Ken's kitchen table and drank copious quantities of Red Zinger tea—not spiked with anything, just straight-up tea. I fell in love with the brew. During the interview we exhausted our supply of tea bags and Ken ran out to the grocery store across the street for more.

Norris's poetry possesses an energy that is hard to explain until one meets Ken Norris. His sense of boundless creativity and constant sense of turning the mundane, the peculiar, the unusual, and the unique into short, stunning poems, has meant that he has outpaced his readers. One of these days, a good critic will catch up with Norris's work and understand and appreciate just how much good poetry he has brought into the world. I feel badly that the interview with Ken did not make it into *Lives and Works*. It should have. Shortly after we did the interview, Ken accepted a teaching post at the University of Maine.

KEN NORRIS

➤ **Brian O'Riordan** and I met at a SAC (Students' Administrative Council) meeting. I was trying to raise funds for a campus-wide literary magazine, the *University of Toronto Review*, and he was the treasurer. He gave us the money. The following summer, after I returned from England where I had fallen ill and lost a huge amount of weight very suddenly, I took up with O'Riordan again in F. W. Watt's graduate class on Canadian poetry. We found that we shared many of the same interpretations of the poets we studied, and we both met up in the Fisher Library's archives, where we studied the manuscripts of the poets we were working on for papers.

The *University of Toronto Review* was in trouble. We were both on the board—I had invited O'Riordan to join the staff before my departure. A new staff member wanted to do 'a confrontational interview' with Irving Layton. I was concerned that the administration (which partially funded the self-supporting annual journal) would cut the magazine's precious funds if Layton was offended. Layton had complained when the same stunt had been pulled at other universities. Brian and I joined forces, and using what we had learned in Frank Watt's class, went in and interviewed Layton. 'You guys are good!' Layton roared. He handed us Leonard Cohen's telephone number. 'Go talk to Leonard.'

The Cohen interview appeared in *Descant*, and both of us were brought onto the editorial staff of what was then one of Canada's leading literary magazines. Off we went, tape recorder and camera in hand, and began our conversations with Canadian authors. Many of the interviews we did have never been published. We also wrote a monograph on Leonard Cohen. Brian and I have remained close friends ever since.

BRIAN O'RIORDAN

~ **Catherine Owen** and I became acquainted as electronic friends before we ever met. She wrote to me to say that she was doing a reading tour for a new book about grief and loss, *Designated Mourner*, and asked if she could come through Barrie to do a reading. I had read her work and heartily agreed. A poet who has had to live with and face the bleak realities of losing a beloved, Catherine writes with a sense of sublime craft that makes the pain all the more poignant. She is smiling in this photograph, but the smile is that of friendship and in many ways masks the pain that she pours into her poetry.

She lives in Vancouver and works in television and movie production, and has been a bass player in a heavy metal band. Goth in her apparel, her poetry is more than simply the utterance of dark tragedy. It is the work of a craftsperson who understands the art of poetry thoroughly and who takes that understanding into the world with workshops and the very useful (from a writing teacher's perspective and a reader's interest) book *The First Twenty-Three*. In preparing this book, she canvassed just about every living Canadian poet, asked their opinions, gathered trade secrets and thoughts on the craft of poetry, and assembled them all into a very readable volume.

When she read in Barrie, she read to a packed house. The store owner where the reading was held, the noted editor and owner of *Pie Magazine*, Sandra Roberts, had the entire space lit in candles. There was a powerful aura of the séance in the room. Catherine Owen's poetry is beyond tragic and borders on the magical, and that magic is what affirms life in her verse—her poems celebrate language and in doing so celebrate life.

CATHERINE OWEN

➤ Victoria was paralyzed by a freak ice and snow storm when I flew into the city with my sister, Carolyn Meyer. We were both there to use the University of Victoria's archives, she for Irish studies and me for their World War I literature holdings. I was also there to interview **P. K. Page**.

Page greeted me at the door, welcomed me graciously (she had impeccable manners), and put the pot on the stove for tea. She was surprised I had made it because most of the roads were shut down and the city of Victoria did not have the capacity to deal with the snow. I was on my own; O'Riordan was working for the Ontario government and had signed off doing interviews. The interview did not go well.

I asked her about various magazines she had been part of as a young poet. 'I discussed that with Eleanor Wachtel,' she said politely. I asked her about the novel she had penned under the nom de plume Judith Cape. 'I discussed that with so and so....' I asked her about her Brazilian years. 'I discussed that with Eleanor Wachtel.' I had read the Wachtel interview and, fine as it was, it did not cover various aspects of Page's life and work that I wanted her to reveal. She was not forthcoming with stories. I had gone all that way for nothing.

I photographed Page in the window of her dining room. She did not want me to open the blinds because she said the light bothered her eyes. The shadows, at least, were co-operative. Before I left, David Godfrey and his wife arrived. I should have photographed and interviewed Godfrey as well. He was vivacious. He wanted to talk. He told me about the founding of Press Porcépic, and how my publisher Tim Inkster had worked for him as a young man. Godfrey was delightful.

P.K. PAGE

➤ **Ted Plantos** was a fixture on the Toronto literary scene. Ted was affable, a great storyteller, extremely funny and encouraging. I met him at one of the Main Street Library readings hosted by Chris Faiers. Ted asked me to read at the Parliament Street Library, and I did one Saturday afternoon to a group of rubbies who were asleep in the back row. Ted lived in the High Park area, but his poetry and his literary work took him into Cabbagetown before Cabbagetown was considered up-market. He was a People's Poet, a designation given to Canadian poets (in honour of Milton Acorn) who write not of academic matters but of real-life, working-class concerns and struggles.

Ted loved baseball, and while I was working on his magazine, *Cross-Canada Writer's Quarterly*, we would sit in his study and talk about the game, how to throw a perfect change-up, and whether the Blue Jays would ever win the World Series. But most of all, Ted loved to talk about poetry. He had been one of the founding editors of *Poetry Canada Review*, with Clifton Whiten when I had written a Markets column for that journal. Ted asked me to contribute to *CCWQ*. I wrote full-out critical essays for his magazine, an experience in feature writing that would serve me well several years later when I was living in Windsor and freelancing for the *Windsor Star* at the request of Marty Gervais.

I loved visiting with Ted, but Ted loved cats, and unfortunately I am deathly allergic to them. I was saddened to learn of his sudden and early death in 2001. Toronto lost one of its most determined and engaged voices.

TED PLANTOS

꙳ Part Pied Piper, part *enfant terrible*, **Robert Priest** has a genius that resides in the fact that he can speak fluently and eloquently to so many audiences while remaining one of the truly good personalities on the poetry scene. He often performs his songs in Toronto with Max Layton. The two make an incredible show.

I have known Robert Priest since I was a young poet. He was one of the regular figures to pop up at open-mic readings at the Axle Tree Coffee House and the Main Street Library. The first time I met him, he had teamed up with Milton Acorn to express his displeasure at the cancellation of the open-mic readings at Harbourfront—a move made by Greg Gatenby, then the Artistic Director of the literary stage—that set Harbourfront on the road to international recognition, although no one knew that at the time.

Robert cut an LP (this was before compact discs or even downloadable music) of his best songs, including one dedicated to Nancy Reagan in which he defended her right to own a gun by saying it was just 'a little gun'. The song referenced the recent death of John Lennon, Priest's hero, who he often quotes. I bought the record. When I moved in with my wife-to-be and we amalgamated our record collection, we realized that not only did we both own copies of Robert's vinyl, but that we both knew him.

When my daughter needed help with a poetry project in her first year of high school she called Robert and he let her interview him. She got an A on the project. Generous, caring, and one of the most empathetic voices on the poetry scene, Robert is playful in his verse and never ceases to be entertaining.

ROBERT PRIEST

◄ We went to see **Al Purdy** at his home on Roblin Lake near Ameliasburgh, Ontario. The entire day was a fiasco. My parents gave Brian O'Riordan and me a lift to Purdy's place and then went for a picnic. Purdy was well away on American beer by the time we got there. A large seagull, possibly an albatross, lay dying in the heat on his front lawn.

Purdy, as a poet and an individual, was protean. He was a shape-shifter. It was hard to get a straight answer out of him. He produced a bust of D.H. Lawrence and force-fed it a bottle of beer when I pointed out that I didn't think it was much of a likeness of the British poet and novelist. 'It looks a lot more like D.H. Lawrence,' he said, 'than I look like Al Purdy.'

We sat at his kitchen table, where this portrait was taken as he smoked a cigar and rambled on about whatever topic he wished. I realized as I sat there, the table awash in beer, and our question sheets soaked in brew, that many of his best poems were written while he sat in that kitchen, looking across the lake at the church steeple that appears in 'Wilderness Gothic', or at the gap in the distant shoreline where Roblin's Mill once stood.

I asked to use the washroom and he showed me to his front porch (the bird was dead by then), and as we stood there he showed me how to write my name on the earth. 'This is how you mark your place in the world, and how you sign it.' At the time, I thought the whole experience was bizarre, but in retrospect Purdy was trying to open to me his very unique world—his love of this place, the earth he lived on, and the locations he knew. Several weeks later, I got a very contrite letter from Purdy. He was sorry about the interview. He sent the answers. He shifted shape yet again and that, in essence, is what summed up Al Purdy for me. He was as fluid as language.

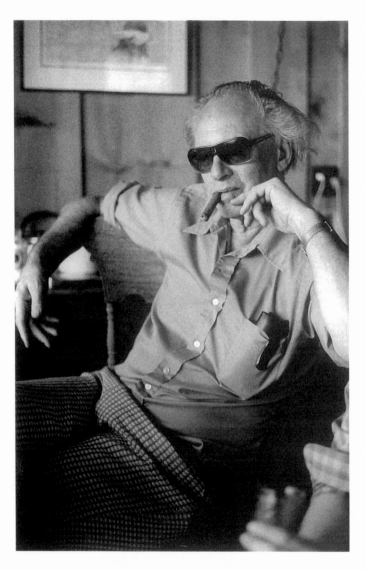

AL PURDY

James Reaney was the master at play. O'Riordan and I went to visit him at his home on Huron Street in the north end of London, Ontario, not far from the University of Western Ontario, where he taught. What immediately stood out about Reaney was that he was an artistic problem-solver, and his means of solving artistic challenges, whether staging dilemmas in his dramas or questions of poetry, was to be playful.

Reaney explained that one of his greatest thrills in theatre was seeing the Peking Opera perform. They were not the typical Western opera, but a troupe that included song, dance, comedy and, above all, a profound sense of inventiveness. In Reaney's work, that often child-like sense of play, the simplicity of design and idea, struck me as something that many artists lose as they grow older and grow up. Reaney never forgot his childhood. When I took this photograph, I wanted to capture that youthful spirit—toes pointed inward, hands innocently clasped and a mischievous smile. Set in the back porch of his house, this is a small stage where a person could enact a miniature drama.

The landscape of Reaney's childhood, the locales of Southwestern Ontario and the region around London, formed an imaginative landscape for him, a place that was all places, a stage on which any drama could be located and enacted. For Reaney, the world was a stage, a place where poetry was hidden in every field or barn or grove of trees. He could see drama where the ordinary eye might easily overlook it, and the passions of the human spirit waiting to be discovered around every corner, or merely out the back door of a person's house.

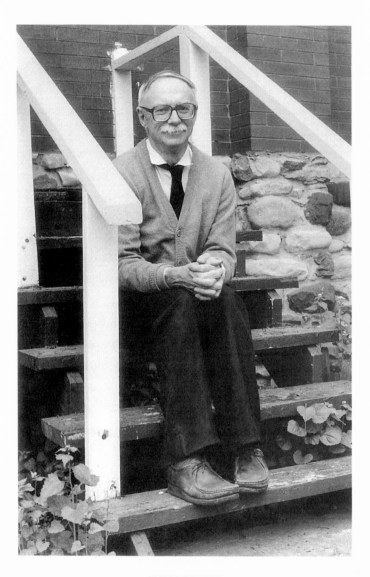

JAMES REANEY

᠅ Although he was born in Baltimore, as was Pier Giorgio Di Cicco, **Michael Redhill** has established himself as one of the voices that knows Toronto best. He has written of the city's lost rivers that cut beneath the streets and skyscrapers, rerouted as sewer lines or kept as secrets that explain why houses in certain districts lean together like bad dental work.

As poet, novelist, dramatist, mystery writer, literary magazine editor, and a voice of great talent, Redhill tackles a wide range of topics, from his family's cottage north of Toronto to the quirky diorama builder of *Martin Sloane*. Redhill is never daunted by finding something new to write about. He was also the editor of the prestigious literary magazine *Brick*. In theatre, he would be known as the proverbial 'triple threat'. That's why I asked him to join the original group of writers who formed the nucleus of the teaching staff for the Creative Writing Program at the School of Continuing Studies when I founded it in 1996.

I decided that if the program was going to be successful, I had to go the old Jack McClelland route of promoting not only the content of the courses, but also the personalities and the artists who would teach the courses. I made bookmarks for each author/instructor, and handed them out at Word on the Street. That's how the program went from nothing to the largest creative writing program in Canada in a matter of weeks. And it helped, considerably, that I had great teachers such as Michael Redhill on board, to bring a diversity of knowledge and ideas to the classrooms. I photographed Michael in his garden in the summer of 1996. He thought he didn't make a good subject for a portrait, but I beg to differ. Here he is as his career was just getting under way, and he is full of confidence.

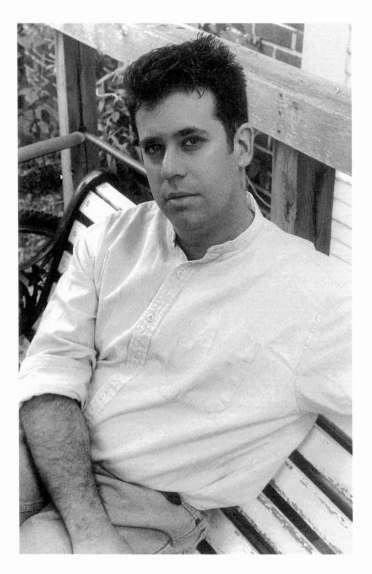

MICHAEL REDHILL

➤ **John Reibetanz** is a gentleman of incredible intellect and refinement. I sat in on his classes when he was teaching poetry at the University of Toronto's Victoria College, and I can attest to the fact that there are few who are as knowledgeable about the art as John. His poetry is structured, formal, precise, yet hauntingly beautiful. He loves to tell stories in his poetry, and a book such as *Ashbourne Changes*, a narrative of the lives and voices that haunt an English country town in both life and death, had a tremendous impact on me in the mid-eighties when I was advised by the American Pulitzer Prize–winner Richard Howard to take my poems apart and put them back together again using meter, rhyme, and traditional prosody. Some contemporary writers knock received forms and the core music that resides in a poetic measure; but I owe John a debt because his poetry taught me that prosody is a necessary part of poetry, even if one has to eventually unlearn it, as was the case with American poet James Wright, and that I could turn to traditional poetics and practise them in Canada, and that I wasn't alone in doing so. John was an inspiration to me.

John was at Stratford the day that Ross Leckie and I went to hear Richard Wilbur speak and read poems such as 'On the Marginal Way'. John was also part of Charles Tomlinson's Canadian tour that I organized, and was a gracious host. John Reibetanz has always valued the idea that poetry is not just about what is written here. His awareness of British and American poetry is vast. I ran into John one day on Bloor Street. I had just photographed Ray Robertson. I asked John if I could take his picture. He obliged, but he said, shyly, 'Only one.' This is the one shot.

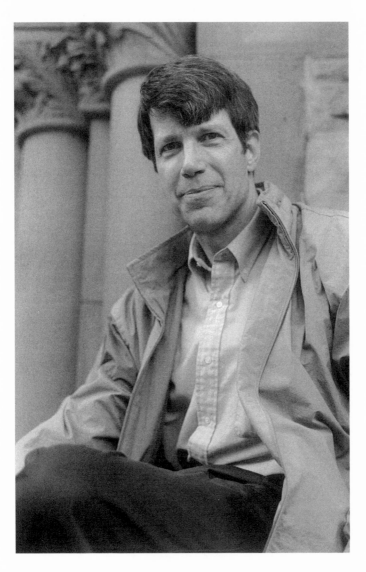

JOHN REIBETANZ

➤ **Ray Robertson** is a force of nature on the Toronto literary scene. I met him in the late eighties at a sesquicentennial reading of Victoria College authors that I organized. Northrop Frye, Margaret Atwood, Margaret Avison, Jay Macpherson and Allan Stratton were there that evening. A shy young man, with long hair parted down the middle and round John Lennon glasses, approached me timidly. He said he wanted to be a writer, and I told him to keep writing. He said he was a student at the college and I told him there were few places as fine to learn to be a writer. He shook my hand, and almost bowed as he backed away.

Fast-forward ten years to a winter morning when I was trying to establish the Creative Writing Program at the University of Toronto's School of Continuing Studies. Someone knocked on the frame of the portable partition that defined my office space. He introduced himself with 'You probably don't remember me, but we met ten years ago', and said he had just returned from Texas, where he had earned an MFA in Creative Writing and had just had his first novel accepted for publication. His jeans were threadbare, and his coat was not heavy enough for the cold day. He said he was down to his last five hundred dollars. I asked him a few questions about fiction writing and hired him on the spot. As he left, I remembered that I wanted to tell him about a writing competition open to Victoria College alumni, so I ran after him and we stood talking for half an hour on St. George Street until he pointed out that I was in my shirt sleeves. Ray took every bit of advice I offered that day and his career took off. He is now one of the premier novelists in Canada, a broadcaster, a critic, and a published philosopher.

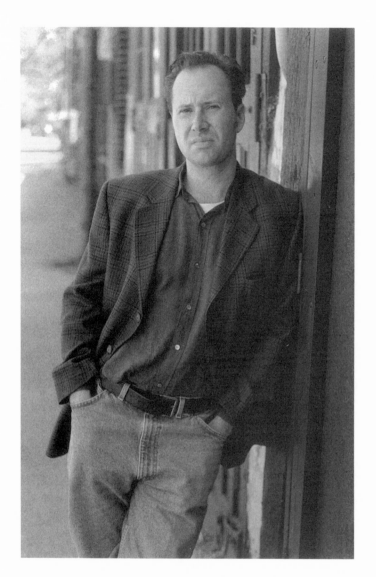

RAY ROBERTSON

➤ Anyone who knows **Leon Rooke** knows there is a lot to him and a lot of him. I picked him up in a limo one morning at his home in the South Annex area of Toronto—an old dairy from the 1840s—and we began our journey to Barrie, where he was to read at Georgian College. I soon realized that he was crammed into the back seat, his long legs awkwardly tucked this way and that. I asked him whether he sat in the back seat or the front seat when he was a Freedom Rider in the Civil Rights Movement in the US south in the late fifties and early sixties. 'The front,' he said, 'with the seat all the way back. The poor guy behind me got squished.'

An actor before he became a writer, when Leon reads he entertains with the enormous number of characters that populate his imagination, his novels and his short stories. Each of them has a unique voice, and each comes alive with a tremendous passion and bravado.

When O'Riordan and I interviewed him, Leon was more laid back, and I photographed him in the window of his study as he relaxed against the frame. His wife, Constance, was still alive when I invited him to read at the Leacock Summer Festival of Canadian Literature in Orillia for which I was Artistic Director for many years. Connie was very ill at that point. After his reading, delivered with his usual gusto, we sat and had tea and scones on the patio of the Leacock Museum's restaurant. Connie looked out of Old Brewery Bay as the sun in a perfectly blue sky shone down on the ducks, ass ends up, probing the bottom for a meal. 'I hope heaven will be like this,' she said. Leon took her hand, and said, 'Yes dear, I'm certain it will be.'

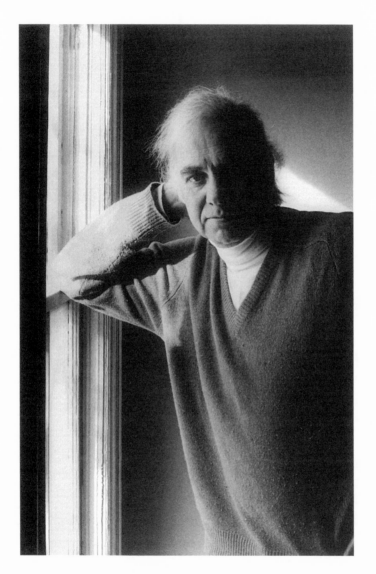

LEON ROOKE

⤳ I had read **Olive Senior**'s work long before I met her. I had edited a textbook of Canadian and international short stories, and the late Chelva Kanaganayakam, a friend and colleague from my three years of teaching at Trinity College in the University of Toronto, highly recommended her. Joseph Bruchac had told me to read her as early as 1982 when I did a reading tour with Ross Leckie, Richard Harrison, and Lawrence Hopperton.

As I was establishing the Creative Writing Program at the University of Toronto's School of Continuing Studies, I heard through the grapevine that Olive, an expatriate Jamaican poet and short story writer of considerable talent, was living in Toronto. I found her number and called her, and she agreed to be among the first authors who taught for me in the program. Assembling that roster of incredible talent—Ray Robertson, Cecil Foster, Austin Clarke—reminded me of the Kurosawa film *The Seven Samurai*, where 'specialists' are studied and recruited for a hopeless mission. I told Olive that the program was self-supporting but that if we had enough students for a class the class would go ahead as scheduled. She agreed and bet on the program that became Canada's largest creative writing program during my tenure as its director.

Shy and soft-spoken but always charming, Olive has garnered numerous awards—deservedly so—and has brought the beauty of her native Jamaica, the often difficult transit to Canadian culture and society, and the lyricism of her voice to the page. This photograph was taken in her apartment in Toronto, a location not far from where Joy Kogawa lives in the north end of Little Italy.

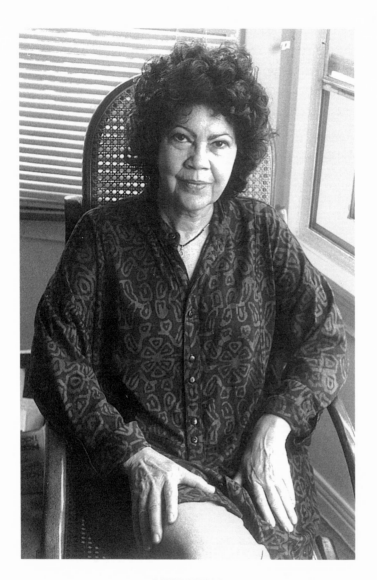

OLIVE SENIOR

⤳ Although we had lived in the same city, Toronto, read at many of the same venues, and knew many of the same people, I had never met **Karen Shenfeld** until I was invited by Colin Carberry to the literary conference in Linares, Mexico, in October 2015. When I heard Karen was coming, I contacted her about what one should know to prepare for Mexico. She had lived for several years in San Miguel de Allende, the picture-postcard city. She wrote back to me with a series of words I should memorize to get by in Spanish, and told me that I had nothing to worry about. Then the hurricane struck Mexico.

I watched in horror as the news reports of devastation rolled in and Linares was dead centre in the path of the enormous storm. Richard Greene, who was also scheduled to participate in the conference, was worried too. We started messaging each other on Facebook. Eventually, Karen picked up the messages and joined in the conversation. Richard and I were booked on the same flight through Houston (the hurricane was headed there after Linares) and we were both considering cancelling our flights. Karen assured us we had nothing to worry about.

Karen is a lyrical poet whose work speaks of the traditions that have informed her past in a haunting language that is both beautiful and memorable. She also has a great voice and entertained the group of international poets late in the evenings as we sat around discussing poetry. I also learned that she is unflappable—and she taught me to take life as it comes, to not worry about what lies ahead as the worst happens less than the best or the near best, and that Mexico was a place of inspiration and visual poetry. It seemed a long way to go to meet someone who had been so near most of my life.

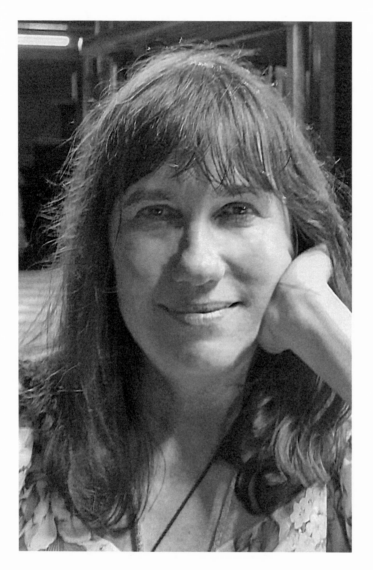

KAREN SHENFELD

꘎ 'My favourite photographer,' **Elizabeth Smart** said as she lit a cigarette, 'is Julia Margaret Cameron, the Victorian photographer.' Cameron had photographed Virginia Woolf when Woolf was a child. She had recorded Tennyson and many other notable English Victorians. She was to British photography what Nadar was to French image-making. In this photograph, taken while Smart was living in Toronto in spy novelist Ian Adams's apartment, I tried to capture a sense of what Cameron would have done had Elizabeth Smart been sitting for her.

There was always a powerful presence of tragic love about Elizabeth Smart. Her voice, although lilting and beautiful, had a waver, not just from smoking, but from weeping. As a young woman, she had fallen in love with the poetry of English poet George Barker, then with Barker himself, who fathered her four children and left her in poverty to struggle for survival. Earle Birney, on learning that she was living briefly in Toronto while Rosemary Sullivan worked on a biography of Smart, remarked, 'She was one of the most beautiful women I had ever seen.'

Smart is remembered largely for her one great masterpiece, the short novel *By Grand Central Station I Sat Down and Wept*, a paean to love and failed love, a brief, poignant narrative that chronicles her relationship with Barker. I asked Birney how he thought she had changed over the years since he had first seen her in Ottawa in the late 1930s, and his response was, 'She looks like she had done a lot of crying.'

What I caught in Smart as O'Riordan and I interviewed her, however, was her ability to fathom the depths of human emotion. She quoted Proust continually on matters of suffering. The one keen eye that looks into the camera speaks of her courage to love.

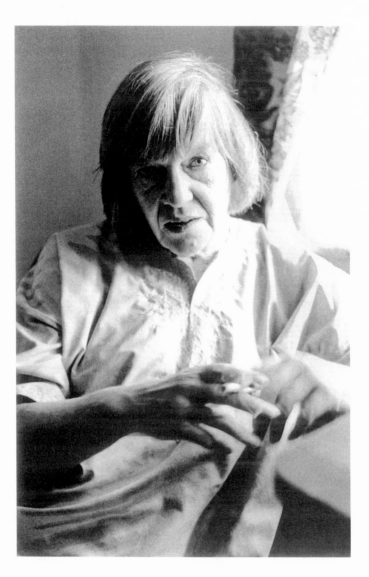

ELIZABETH SMART

➤ **Raymond Souster**'s skin was pale and almost transparent, a result of working most of his life in the Bank of Commerce's vault two stories below street level. Despite his quiet demeanour and precise and reserved manner, Souster was one of Canada's most prolific poets. He was also a devotee of the game of baseball. When he came to my parents' house for the interview O'Riordan and I did with him, the indoors simply did not suit him and I persuaded him to walk with me to the diamond in the nearby park, where I had played pickup games of baseball with my friends.

Souster was one of Canada's foremost Modernists. His correspondence with William Carlos Williams, and his work as a poetic guide for many young poets—among them Atwood and Deahl—did much to shape the literary landscape, not only of Toronto but of Canada. His poems are moments of insight and vision, glimpses of passing fragments of reality that are given sublime importance by the way in which he perceives them with irony.

For many years, I lost touch with Souster. I heard through James Deahl that he was still alive, in his high nineties, and was bedridden in a nursing home on the north side of Bloor Street opposite High Park. I went to see him. I was startled to see a diminutive figure wrapped in a white bedsheet. He was blind, and his body was riddled with cancer. I thought I would be talking to a corpse. Instead, when I pulled up a chair next to his bed and told him who I was, he started to recite the better part of one of my books of poetry. We talked for over six hours about Modernism, jazz, poetry. His body was gone, but his memory and his voice were more powerful than I ever remembered.

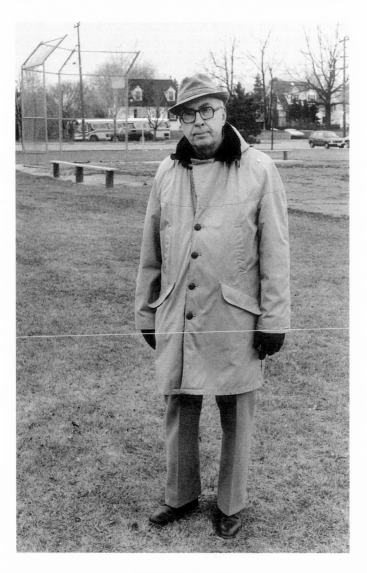

RAYMOND SOUSTER

⤳ An actor by nature and profession, and a playwright by occupation, **Allan Stratton** is one of the liveliest characters I have met. Whenever I run into him, whether through Victoria College or simply on the street in Toronto, he overflows with enthusiasm and good humour.

O'Riordan and I interviewed Allan in 1990, but the piece has never been published. It ended up being cut from *Lives and Works* due to space considerations. I have always felt that was a shame. I thought at the time that having a playwright in that volume, someone who could transform a lamppost outside the University of Toronto Bookroom on College Street, and make it work as a set for his moment of storytelling, needed to be in the book.

Born in Stratford and educated at Victoria College, Allan is another product of the brilliant tutelage and creative problem-solving of James Reaney—a presence in Canadian literature who was instrumental in the careers of Marty Gervais, Tomson Highway, John B. Lee, and many others. For Reaney, and for Stratton, every moment is an opportunity for theatre. The commonplace is filled with wonder. The places where one lives are rich with stories waiting to be brought to life either through narrative or dramatic action.

Allan gained early acclaim for his play *Rexy!* about Mackenzie King. Stratton's works are a combination of satire, Canadian Gothicism, and careful craftsmanship. He is, arguably, the greatest dramatist Canada has produced in the last fifty years, and his works have been performed throughout the world.

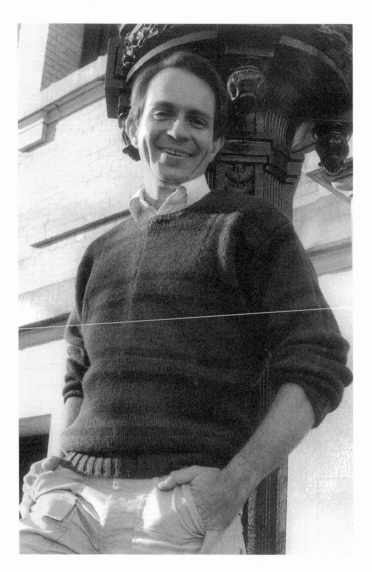

ALLAN STRATTON

༝ࡇ **Ania Szado** is a writer of fashion—not in the glossy, magazine sense, or even the facile mode of trendiness, but in the way she can depict the beautiful and the poignant from the past and animate them with a luxuriousness of language and narrative. I first met Ania when Fred Addis and I invited her to the Leacock Festival in Orillia, where she read under a huge tree on the lawn between the house and the lake.

Several years later, I was one of the judges for a major fiction prize and read her novel about Antoine de Saint-Exupéry, the French aviator and author of the beloved children's classic *Le Petit Prince*. The novel focused on de Saint-Exupéry's time in New York during the Second World War when he was romantically involved with two women, both of whom were connected to the New York fashion scene. More than simply a historical accounting of the period and the characters' experiences, *Studio Saint-Ex* is a luxurious recreation, in tone, language, and image of the end of the great period of glamorous haute couture that connected Paris designers directly to the wealthy New York market. I decided that Ania's novel was the best of the submissions, but was voted down by the other judges. What Ania Szado achieved in that novel was a paean to taste and elegance that is often missing in Canadian fiction. Readers in other countries agreed with me, especially in Europe.

I invited Ania to come to Barrie and give a reading, and this photograph was taken in the summer of 2015 when she took part in the monthly Word Up reading series at the Unity Market Cafe—a series I was involved in organizing during its first years of existence.

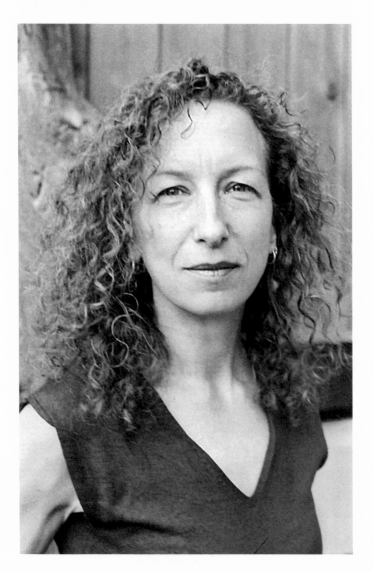

ANIA SZADO

➤ I sat down in my office one morning at the School of Continuing Studies and switched on my computer. Email and the internet were in their very nascent days. The idea of a life in the electronic world was entirely new. At that point, I did not exist on the web. Out of nowhere, it seemed, I received an email from an architect and poet in India who seemed to know all about my poetry and wanted to learn more about poetic forms such as the villanelle. I had no idea where he had found information about me. I responded with, 'Who are you?'

H. Masud Taj and I began our long friendship and correspondence that morning. Within a year he moved to Canada, partly to find a better life and partly to escape the violence that was tearing his community apart. Canada seemed a safe place. He came to Toronto not long after he arrived in Canada and I arranged for him to give a reading at Hart House. He stood in front of the audience, not a note in sight, and recited for over an hour. Taj is an oral poet. I told him, 'You've got to write that down.'

Several years later, Taj arrived in Barrie with the poems he had composed in his mind set to paper. I started reading through them and commented on them, and his response was, 'You've got to write that down.' I did. Not long after that, Michael Callaghan said he was looking for a book combining poetry and prose. I sent him *Alphabestiary*, an emblem book of animals which contained Taj's poetry and my prose commentary. The book sold out in a month. Emblem books were popular from the Middle Ages up to the early nineteenth century. Each animal had its own poem on one page and its own exegesis on the opposite. And when the book closed, east met west. Together, Taj and I did a roadshow performance of the book that we took all over Ontario to packed houses. Brilliant, witty, erudite, Taj is one of the most remarkable writers I know and is a very close friend.

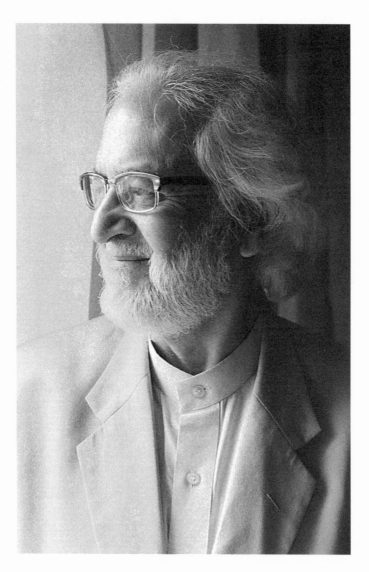

H. MASUD TAJ

➤ A world traveller, having being born in London and lived in Barcelona and Beijing, **Royston Tester** creates work that is an expression of an international consciousness. He feels as at home in the Far East as in the east end of Toronto. Erudite and a natural storyteller, Tester gives form to the idea that Canada is connected to the world, especially by virtue of the lingua franca of the English language.

I met Royston when Halli Villegas threw a launch party for my book *The Obsession Book of Timbuktu* at a restaurant in downtown Barrie. Halli had not published my book, but she thought it was worth celebrating coincidentally with the launch of her own Tightrope titles. A product of the Humber School of Writers, Royston teaches ESL classes at McMaster University, a trade he plied while living in China. He loves to talk about the universality of English, how it is a ticket to the wide world, and how it attracts words, ideas, and experiences from all over the globe while finding a myriad of ways in which those subjects can be communicated to a reader.

There are few places in the world where Royston has not been, and his stories convey a feeling of wanting to embrace everything—not that they are the least bit diffuse, but that they are open-eyed. His characters move through the world as if they are moving through an encyclopaedia of the learning process. They desire to know and to be known. They are the work of a writer who is very much a citizen of the world.

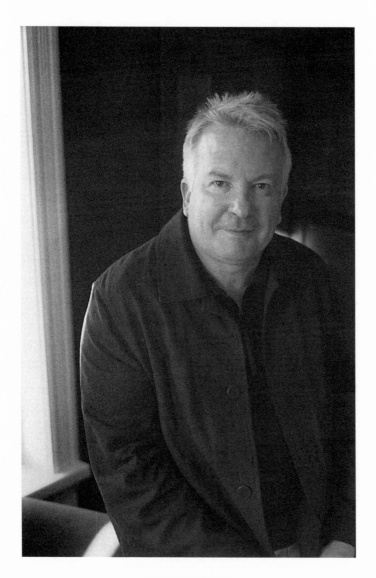

ROYSTON TESTER

Halli Villegas reminds me that we met when she was working in a shop near my parents' home. I bought a small leather change purse from her for my wife, Kerry, who I had just begun to date. Halli and I kept running into each other around Toronto. My wife would ask, 'Who is that?' and I would reply, 'I don't know.' Two years later, Halli turned up in a poetry workshop I was running at the University of Toronto. Her writing was outstanding. I had discovered a genuine talent. I introduced her to Austin Clarke and she became a regular member of our martini club. I also introduced her to a publisher, and he hired her for her secretarial skills. I was not surprised to learn that she had left the publisher to start her own imprint, Tightrope Books, a press that has become one of the leading houses for genre fiction and new women authors.

Halli was born and raised in Detroit. She is proud of her Mexican roots. She is also passionate about language, and has published over five books of poetry and short fiction. In the summer of 2014, Halli and her husband, David, invited me to join them on a trip to New York, where I gave a reading in Bryant Park just prior to the release of a collection of my short stories that Tightrope published.

Willing to tackle just about every form of writing from sci-fi to erotica to sestinas, Halli is one of the most versatile and broadly imaginative authors I have known. She loves to talk about literature—especially her heroes Nabokov and Shirley Jackson—and is one of the best-read writers I know. My wife and I visit with Halli and David at every opportunity and enjoy their kindness, generosity, and their friendship. This photograph was taken on their back deck when they were living in Barrie prior to moving to Mount Forest.

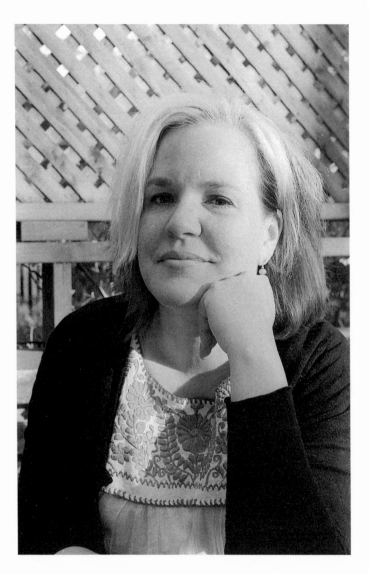

HALLI VILLEGAS

➤ The loss of **Bronwen Wallace** to cancer at a young age was a blow to Canadian literature. Bronwen was a natural storyteller with gifts that she applied to the art of poetry. She would write about her childhood, about growing up and living in Kingston, Ontario, and about the people she loved. She was a remarkable individual. O'Riordan and I interviewed her in her home in Kingston. When we finally got around to typing up the transcript of the conversation, there was a long delay before I heard back from her with any corrections she wanted to make to the interview.

She called me one morning at my parents' home in Toronto. She told me she had taken a long time to go over the piece because she wanted it to be just right. We discussed the changes that she had made. I corrected the text to her liking. When I said that this would go down in posterity as the first major interview with her, she added with a sigh that it would likely be her last interview for a while. I did not know, and she did not say a word about it in the interview, but she had jaw cancer. Two months later, I was surprised to learn she had passed away.

There was a beautiful simplicity to her poetry that expressed a warmth and inclusiveness that I felt when we arrived at her home. We sat around her dining-room table, drank coffee, and joked about Kingston and its penitentiaries, and how her life had been spent in the one city. She said, 'Writing a poem isn't a cathartic experience. I don't write to purge myself. I use narrative form because what I hear in my head is a conversation.' The conversation should have lasted longer. She was a good person and a very fine poet.

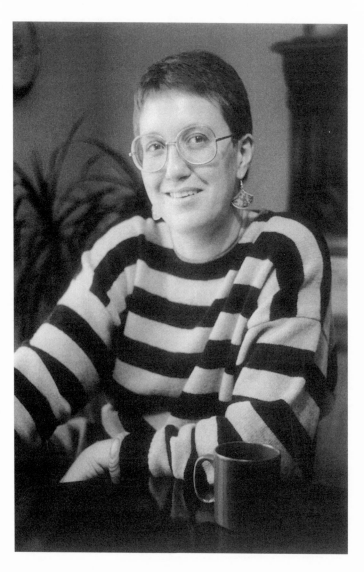

BRONWEN WALLACE

⤙ **Robert Weaver**'s work filled my Sunday nights. Each week, he produced the program that writers and readers tuned in to hear on the CBC: *Anthology*. The deep voice of Harry Manus would open each program, and every episode would conclude with Morley Callaghan 'stopping by to chat'. It was an hour that brought Canadian literature to every part of the country at a time when literature in Canada was struggling to survive and to introduce a new generation of authors to the public. (Among those authors was a short story writer from Wingham, Ontario, Alice Munro.)

Weaver's contribution to Canadian literature during the sixties and seventies has not yet been fully measured. As well as producing a weekly radio show, he and William Toye, an editor at Oxford University Press and the publisher of such poets as Margaret Atwood, P.K. Page and Patrick Lane, ran a magazine, *The Tamarack Review*. *Tamarack*, as it was known, was the vehicle that brought French Canadian writers such as Gabrielle Roy, Anne Hébert, Gaston Miron and Marie-Claire Blais to English readers, and did much to bridge the two solitudes that defined Canada at that time. As well, in its pages Al Purdy, Irving Layton, Earle Birney, and many others could be found. The magazine lasted for eighty issues.

The Tamarack Review was where every young poet wanted to be published. It was a sign that a poet or writer had made it into CanLit. My work was accepted by the magazine and was scheduled to appear in issue eighty-one, but alas, the magazine shut down, one issue short of my goal. O'Riordan and I interviewed Weaver in his office at the CBC and he told us the story of his work in CanLit. Unfortunately, the interview has never been published. This photograph was taken in the Jarvis Street building.

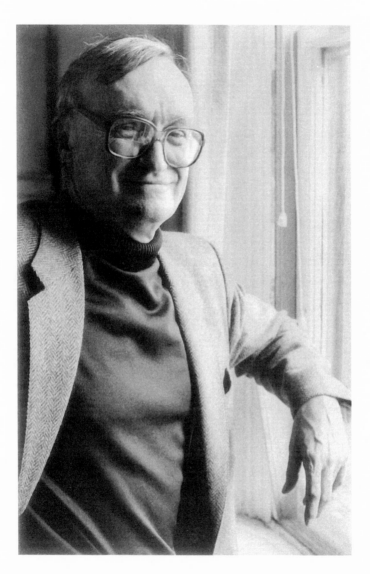

ROBERT WEAVER

James Deahl pulled a copy of Al Alvarez's anthology, *The New Poetry*, out of his briefcase one night when we were hanging out at the Duke of York during my undergraduate days, and read a poem, 'Birth of a Shark'. There was a splendid line, 'The shark ran aground on its shadow.' He repeated it over and over. I asked who wrote it. It was by a Canadian, **David Wevill**. I decided I had to meet Wevill.

Wevill's biography said that he was born in Canada, educated at Cambridge, and taught university in Burma. He had married a Palestinian-Canadian poet who had been a student of Earle Birney's, Assia Gutmann, and had been caught up in the tragic machinations of the breakdown of Ted Hughes and Sylvia Plath's marriage. I tried to learn more about him when I lived in England. The subject of my PhD thesis, Howard Sergeant, said that David, following the suicide of Plath and then Gutmann, had gone to live in Spain and that was the last anyone had heard of him. I traced Wevill to Austin, Texas, but the trail went cold there.

Jeffery Donaldson was walking through the basement offices at the University of Texas when he saw the name D. Wevill on a door, and knocked on it. David Wevill answered. Jeffery told David that a Canadian named Meyer had been looking for him. That is how I met David. After he had come to Toronto, Barry Callaghan had found him and wanted to do a selected poems but several poets had already failed to pull David's five-hundred-page manuscript together into a one-hundred-and-fifty-page book. Barry gave me the manuscript and I succeeded. David became a mentor to me during my doctoral and post-doctoral work in Texas. He writes of matters of the heart and taught me how to make my poetry connect with its verities.

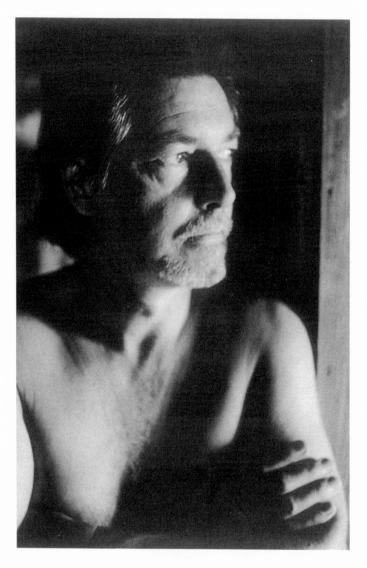

DAVID WEVILL

Life in Windsor was a disaster for **Adele Wiseman**. She had been invited to be writer-in-residence there during the year I was teaching for the university. She had been moved from house to house because the university was developing the streets where they had houses of grace for visiting scholars. Her furniture had been broken, and many of her mother's precious dolls had been damaged beyond repair.

A lifelong friend of Margaret Laurence, it was Wiseman who achieved fame first, with her 1957 novel, *The Sacrifice*, a book that I have often put on the curriculum of my Canadian literature courses. There is a greatness in that book. When O'Riordan and I interviewed Adele in Windsor, she was in the midst of performing *The Doll Show*, a free-style production (sans script) in which she talked about how her mother had taken household objects and had made over a thousand dolls. Each doll was a character, with a name and a story. The show was a tribute to the imagination as much as it was a moving recital of her relationship with her mother. In this photograph, taken during a rehearsal (Adele said she didn't need rehearsals and they were someone else's idea), she is seated with her beloved dolls, ready to tell their stories.

When Adele returned to Toronto, she was told she had cancer and had only months to live. I visited her at her daughter's apartment, where she was staying, sleeping on a futon on the living-room floor. We sat for hours, talked about life and literature. When she said she was tired, I rose, said goodbye. I never saw her again.

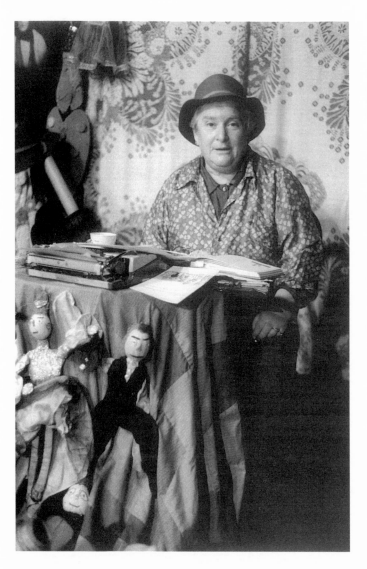

ADELE WISEMAN

I met **Elana Wolff** at a reading for the Rower's Club Series in Toronto. She came up to me prior to my set and was positively effusive. 'I want to be the editor of your poetry!' she exclaimed. I had been in touch with Guernica Editions editor Michael Mirolla, who said he liked my poetry but would prefer to publish my short stories. I hastened to explain the situation with Guernica Editions. Elana seemed disappointed, so I invited her to come and give a reading of her work in Barrie.

I had heard of Elana many years before our actual meeting. I had received a telephone call from Malca Litovitz, a very brilliant and accomplished Toronto poet whose work chronicled her Jewish background with incredible passion, detail, and a gifted poetic voice. I made a number of suggestions to Malca as to which publishers would be best for her work—she did not have a publisher at that point—and one of the publishers I suggested was Guernica Editions. I did not know that Elana was a close friend and editor of Malca's work at that point.

Several months later, I was saddened to learn of Malca's passing. She had not told me she was ill. At first I thought that Malca's poetry would disappear, as has been the case with so many gifted poets who died before their careers peaked and their work was securely in print. I was relieved to learn that her work had found a publisher, and a very fine editor in Elana.

Elana Wolff writes with profound beauty and delicate gracefulness of her Jewish culture and the people, places, and things from that culture that have shaped her experience. Her poetry is passionate because it expresses what it sees and feels with a tremendous sense of caring for language. The poet and the editor find their creative partnership in Elana Wolff's work, and the resulting poems are memorable and lasting because of it.

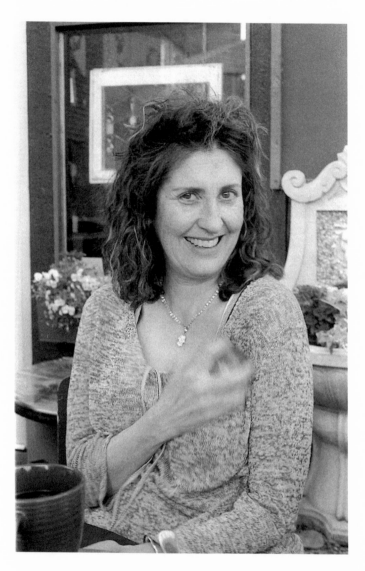

ELANA WOLFF

Acknowledgements

This book would not have been possible without the professional and personal dedication of those who have assisted me on my thirty-year journey through the printed word and the personalities that have gone into the making of a significant period in Canadian literature.

My thanks to Adina Sarig of Adina Photo in Toronto, who was the first printer for my early images and who took great care with each one and developed the rolls of film in the darkroom process that is now almost a lost art; Karen Wetmore of Grenville Printing at Georgian College in Barrie and her staff for the first scans of the accumulated images; Toronto Image Works for their work with some of the newer images; and a very special thanks to Keith Butler and Matt Butler of Extreme Imaging in Barrie for their fine eyes, patience, understanding, outstanding technical expertise, and thoughtfulness with much of the digitization of my photographs.

Thank you to Brian O'Riordan, my compadre on much of the early journey through the faces and works of Canadian literature; to James Polk (formerly of Anansi Press) for his early belief in the interviews Brian and I did; to Marty Gervais of Black Moss Press for supporting the second volume of interviews that Brian and I assembled; and to Karen Mulhallen of *Descant* magazine for publishing several of the early interviews and the images that accompanied them.

A special thanks is owed to Chandra Wohleber for her keen editorial eye on the text and to Stephanie Small of the Porcupine's Quill for her work in support of this book. A very special thank-you to Tim and Elke Inkster of the Porcupine's Quill. It was their belief in these images, their patience, their caring, and their profound love of detail in both text and image that brought this project together. To my good friend Tanya Singh for coming through for me when I needed

her assistance; to my mother, Margaret Meyer, who carefully cata- logued the files of photo negatives and contact sheets for preserva- tion when I could not see the value in them; to my sister, Dr Carolyn Meyer, for her artistic eye and her generosity of creative spirit; to my wife, Kerry, for her unfailing support and her dedication to this project; and to my daughter, Katie, who rescued these images from a forgotten filing cabinet and insisted that I bring them to light and continue the process of recording the faces of those who have made Canada's literature over the past thirty years. And above all, thank you to all the authors who permitted me to photograph them.

About the Author/Photographer

Bruce Meyer has spent most of his life in an ongoing conversation with Canadian literature and Canadian letters. Known across Canada for his broadcasts on the CBC with Michael Enright on *The Great Books, A Novel Idea*, and *Great Poetry: Poetry Is Life and Vice Versa*, Meyer is author of forty-nine books of poetry, short fiction, non-fiction, literary journalism and pedagogy. With Brian O'Riordan he produced two books-interviews with Canadian authors: *In Their Words* (1985) and *Lives and Works* (1991). As a poet, he won the E.J. Pratt Gold Medal twice, the Gwendolyn MacEwen Prize for Poetry, and the IP Prize in the United States, and was runner-up for the Indie Fab Award and the Cogswell Prize. Among his poetry books are *To Linares* (2016), *The Seasons* (2014), *The Madness of Planets* (2015), *The Arrow of Time* (2015), *Testing the Elements* (2014), *The Obsession Book of Timbuktu* (2013), *A Book of Bread* (2012), *Mesopotamia* (2010), *Dog Days* (2010) and, with H. Masud Taj, *Alphabestiary* (2012). His 2000 book on the Great Books, *The Golden Thread*, was a national bestseller, and was followed by *Heroes* (2007). With Barry Callaghan he was co-editor of the landmark anthology *We Wasn't Pals: Canadian Poetry and Prose of the First World War* (2000, 2014), and with Carolyn Meyer he was co-editor of the groundbreaking anthology *The White Collar Book* (2011). Meyer is professor of Creative Writing and Communications at Georgian College in Barrie, and an Associate at Victoria College in the University of Toronto where he teaches in the prestigious Vic One Program. He was the inaugural Poet Laureate of the City of Barrie from 2010 to 2014, and lives there with his wife, Kerry, and daughter, Katie.

(Opposite: photo by Carolyn Meyer, August 1979, Kenilworth Castle, England)

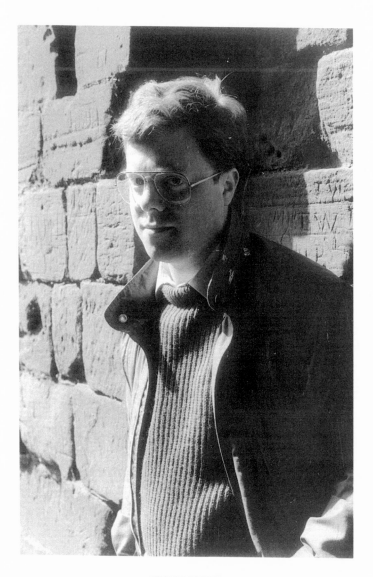

BRUCE MEYER